DATE DUE

DEC 1 2 1995	
APR 0 5 1996	
JUL 1 0 1996	
FEB 1 0 1997	
MAR 2 2 1997	
MAY 2 0 1997	
DEC 1 4 1997	
Feb 3, 1998	
JUN 0 9 1998	
JUN 1 8 1998	
OCT 1 6 1998	

DEMCO, INC. 38-2931

Leonardo
da Vinci
Anatomical
Drawings

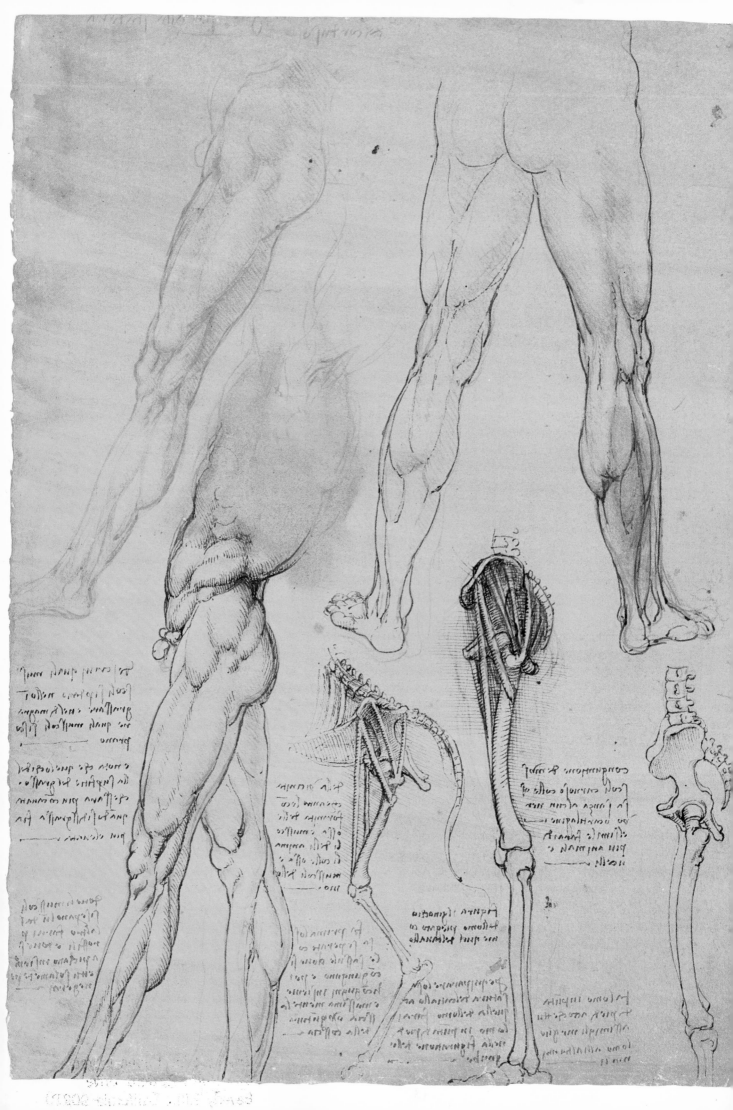

Leonardo da Vinci

Anatomical Drawings

*from the
Queen's
Collection
at
Windsor
Castle*

Los Angeles County Museum of Art

Exhibition dates:
National Museum of History and
Technology, Smithsonian Institution
July 2–August 1, 1976
Los Angeles County Museum of Art
August 5–September 5, 1976

The Corpus of Leonardo's Anatomical
Studies at Windsor will be
published in a facsimile edition by
Academic Press, Ltd. (London)
a subsidiary of
Harcourt Brace Jovanovich, Inc.
(New York) which has generously
supported this catalogue.

ISBN 0-87587-072-4
Library of Congress
Catalog Card Number 76-19378

Published by the
Los Angeles County Museum of Art
5905 Wilshire Boulevard
Los Angeles, California 90036

← Frontispiece
7. *A Comparison of the
Legs of Man and Horse*
(actual size)

The catalogue was produced
in Los Angeles, California.
Design by Ken Parkhurst.
Text set in Baskerville type
by R S Typographics.
Printed on Warren's Lustro
Dull paper by Welsh Graphics.

Contents

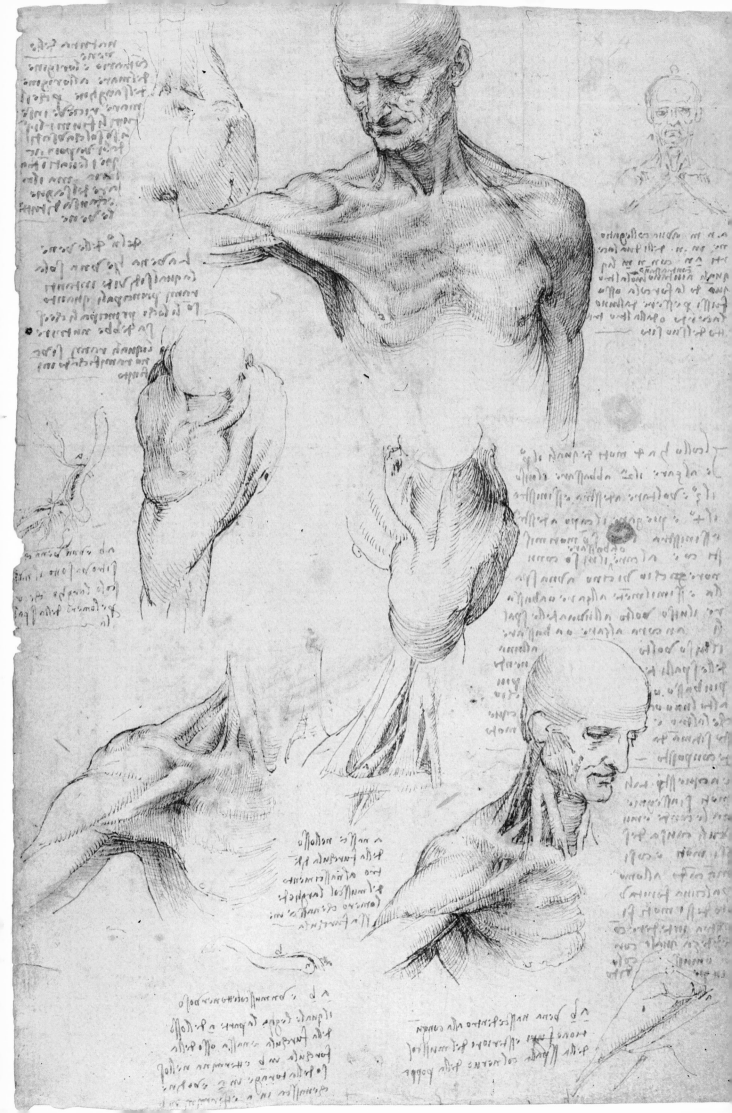

Foreword

This exhibition is part of the celebration of the American Revolution Bicentennial and takes place only in two cities of the United States—Washington, D.C., and Los Angeles. It opens at the National Museum of History and Technology of the Smithsonian Institution in July on the occasion of the visit of Queen Elizabeth II, and then will be seen in August at the Los Angeles County Museum of Art.

The choice of these two centers has been determined in part by their preeminent role in Leonardo studies in America. It was in Washington that the first comprehensive study of Leonardo as an anatomist, the now classic and still unsurpassed book by J. Playfair McMurrich, appeared in 1930 as a project sponsored by the Carnegie Institution, a book inspired by George Sarton and Charles Singer, whose names have come to be associated with America's greatest contribution to the history of Medieval and Renaissance science. And it was in Washington at the National Museum of History and Technology in 1974 that a collection of original folios from the Madrid Codices of Leonardo was displayed for the first time. In Los Angeles, some forty years ago, Dr. Elmer Belt initiated that center of Leonardo studies which is now known the world over as The Elmer Belt Library of Vinciana at the University of California, Los Angeles. The impulse given by this institution to Leonardo studies in general and to the study of Leonardo's anatomical manuscripts in particular is best represented by such publications as Professors O'Malley and Saunders' *Leonardo on the Human Body*, O'Malley's edition of *Leonardo's Legacy*, and Dr. Belt's own *Leonardo the Anatomist*. And it was on the occasion of a visit by Lord Clark to the Belt Library in 1964 that a new edition of *The Drawings of Leonardo da Vinci in the Collection of Her Majesty The Queen at Windsor Castle* was planned as the joint work of Lord Clark and Carlo Pedretti. Five years later the project was accomplished.

Gratitude is due Sir Robin Mackworth-Young, Royal Librarian at Windsor Castle, who with Professor Pedretti planned this exhibition for the Smithsonian Institution and the Los Angeles County Museum of Art; the Honorable Mrs. Roberts, Curator of the Print Room at Windsor Castle for coordinating both exhibition and catalogue; Sir Anthony Blunt, K.C.V.O., P.S.A., for the catalogue introduction; Dr. Kenneth D. Keele, F.R.C.S., for his essay and medical commentary to the individual catalogue entries adapted by Lady Roberts from the Clark-Pedretti volumes; and, above all, Her Majesty Queen Elizabeth II, for sharing these drawings with the people of the United States.

14.
← *The Surface Muscles*
of the Neck and Shoulder
(actual size)

S. DILLON RIPLEY
Secretary
Smithsonian Institution

KENNETH DONAHUE
Director
Los Angeles County Museum of Art

Introduction

Leonardo da Vinci is recognised as one of the greatest geniuses of the Italian
Renaissance. Others may have equalled him as an artist, but no-one else
possessed in such a high degree that curiosity about the physical world which
is the foundation of modern science, combined with mastery in the arts of
painting, drawing, sculpture, and even architecture.

The full range of his talent and interest can be seen, as nowhere
else, in the drawings—around six hundred in all—belonging to The Queen
and preserved in the Royal Library at Windsor Castle.

In addition to his beautiful studies of human figures and heads, his
dramatic mountain landscapes, and his brilliant drawings of horses, there
is one group of drawings which have always excited the interest of scientists
as much as of art-historians: the studies of anatomy, of which twenty-five
are shown in the present exhibition.

As Dr. Keele points out in his essay "Leonardo da Vinci the Anatomist"
(pp. 11–14), Leonardo's anatomical drawings show a knowledge of the ana-
tomy of human beings and animals, based on actual dissection, which exceeds
that of his contemporaries in the medical profession. To this was added
the greatest skill in recording his discoveries on paper, for it must never be
forgotten that these studies are not only fascinating scientific diagrams but
superb works of art.

The history of the Leonardo drawings at Windsor is complicated and in
some parts obscure. The artist bequeathed his papers, including all his draw-
ings and manuscripts, to his favourite pupil Francesco Melzi, whose hand-
writing may be seen on No. 21 verso of the present exhibition. After Melzi's
death ca. 1570 his son sold the greater part of the Leonardo collection to the
sculptor Pompeo Leoni who took the material with him to Spain. After Leoni's
death in 1609 the corpus of Leonardo material was dispersed: at least two
volumes of notes and drawings remained in Spain and were recently discov-
ered in the Biblioteca Nacional in Madrid. At some date before 1630, however,
another volume of drawings was acquired by the great English collector Lord
Arundel, who was adviser to King Charles I on artistic matters. At this time a
number of the Leonardo drawings were engraved by Hollar, including part of
Nos. 2 verso and 14 recto of the present exhibition. In 1645, on account of the
Civil War, Arundel left England and settled in Amsterdam, and almost cer-
tainly took the drawings with him. The next time we hear of the Leonardo
drawings is in 1690 when they were shown to the Dutch statesman and collec-
tor Constantin Huyghens during his visit to Kensington Palace. He was shown
them by Queen Mary II who, with her husband King William III, had ascended
the English throne as joint monarchs in the previous year. How the drawings
entered the Royal Collection is not known, but it has been suggested that they
were acquired by King Charles II from the court painter Sir Peter Lely, one of
the greatest collectors of drawings of his time. On the other hand, Count

Galeazzo Arconati, who gave the Codex Atlanticus and other Leonardo manuscripts to the Ambrosian Library in 1637, knew of Leonardo's treatises on colour and anatomy and mentioned them in 1634–1639 as being "in the hands of the king of England." The information probably originated from Lord Arundel himself (who had tried to purchase the Codex Atlanticus from Arconati) and possibly refers to the corpus of Leonardo's anatomical studies now at Windsor, which includes a four-page sheet entirely devoted to optics and colour theory.[1]

By 1930 all the drawings had been taken out of the volume in which they had been bound up by Leoni—the binding with his name on it is still preserved at Windsor—and in that year the greater part of the anatomical drawings were set into the sheets of three new volumes. Recently it was found that this arrangement was unsatisfactory and the drawings were removed and set between two sheets of clear acryllic for their better preservation. Thus protected they can, for the first time, be exhibited separately and in such a way that both sides of the sheet can be seen. The new mounts have also made it safe to send them across the Atlantic for the present exhibition.

The drawings have recently been examined under ultra-violet light and in some cases parts of the drawings which had faded have become visible. This is due to the fact that these particular drawings were made with a metal point —of silver, gold, or lead—and the deposit of metal which it left had almost entirely disappeared, leaving a quantity too minute for the eye to see but large enough to fluoresce under ultra-violet light. The results of this experiment, which have brought to light several drawings of horses, a number of important details in the anatomical drawings, and important architectural sketches, were recorded by photography and will be published in an article in *The Burlington Magazine* later this year. Two examples of these "rediscovered" drawings are included in the present exhibition and in each case the ultra-violet photograph is exhibited alongside the original (see Nos. 1 verso and 4 recto).

ANTHONY BLUNT

[1]Nos. 19149–19152.
Cf. C. Pedretti, *A Commentary on Leonardo da Vinci's Literary Works,* London, 1975, Vol. 1, Introduction.

Leonardo da Vinci The Anatomist

To say that Leonardo da Vinci was a unique genetic mutation is perhaps only to put into modern language Vasari's sixteenth-century verdict that "his genius was the gift of God." But this gift or mutation was expressed not only in his intellect but in his physique also. Moreover Leonardo's approach to the anatomy of the human body was significantly influenced by his own remarkable physical attributes. According to Vasari, he combined in himself exquisite sensory sensitivity with great physical strength and dexterity, if we may use this term for a man whose writings and drawings throughout his life were left-handed. And it so happens that his work in anatomy falls into two clear-cut periods of his life which correspond to those sensory and motor attributes of his nature.

Leonardo's remarkable genetic endowments were derived from a peasant girl, Caterina, and a Florentine notary, Ser Piero da Vinci. Their bastard son, Leonardo, was born at Vinci on April 15, 1452. From a very early age he is said to have shown exceptional ability in geometry, music, and artistic expression. Ser Piero, noticing this, took his son's drawings to his friend Andrea del Verrocchio in Florence. Verrocchio was so struck by their quality that he accepted the promising young man straight away into his workshop. Verrocchio himself was well aware of the importance of perspective in art as well as the potential enrichment to art of representing the human body by a knowledge of anatomy. Like Leonardo he was an unlettered man, unimpeded by traditional learning from personal observation and the practical application of his ideas.

In a neighbouring *bottega* the brothers Antonio and Piero del Pollaiuolo were similarly anatomically minded, using their knowledge as a basis for such pictures as the *Martyrdom of Saint Sebastian* (London, National Gallery). Such a background provided Leonardo with an ideal point of departure for his own painting of Saint Jerome (Rome, Vatican Museum) in which the anatomy of the head and neck so dramatically portrays the agony of his soul.

Perspective, however, was a less congenial subject to Verrocchio who was daunted by its geometrical requirements. Not so Leonardo who forged ahead in this field, basing his studies on the work of Leon Battista Alberti and Piero della Francesca. From experimental observations of objects through a vertical glass pane, or *pariete,* Leonardo came to appreciate the relation between perspective and the quantitative or measured observation of external bodies in their true proportions. This realisation led him to apply himself to the objective representation of machines with such a degree of measurable accuracy that they have been reconstructed in recent years. It soon occurred to Leonardo that the same perspectival principle could be applied to extract "true knowledge" from the "universal machine of the earth." And what applied to the macrocosm of the Earth applied also to that microcosm, the

living body of man, which like the great "terrestial machine" is "enclosed in the sphere of air."

Thus Leonardo's early explorations into human anatomy focussed on the nature of "experience," and in particular of perspectival experience. It is mainly in these early years, about 1490, that we find his many diatribes against the "authorities." For instance: "Many will think that they can with reason blame me, alleging that my proofs are contrary to the authority of certain men held in great reverence by their unexperienced judgements, not considering that my works are the issue of simple and plain experience which is the true mistress" (Codex Atlanticus f.119va). This was written during those very same years during which he was carrying out diligent and painstaking experiments on perspective, as well as his first anatomical dissections.

In this first period of Leonardo's anatomical studies, from about 1487 to 1493, it is interesting to observe how dissections of the sensory nervous system, particularly those parts concerned with vision, predominate. This assertion is only apparently contradicted by the fact that the finest perspectival drawings of the human skull that he ever made were drawn at this time. One notices, however, that the text alongside these early perspectival drawings of the human skull (as, for example, No. 2 recto) is largely devoted to the location of the centre of the senses and vision in the skull. Here the system of crossing lines is mainly devoted to demonstrating the site of "the confluence of all the senses," that is, the *sensorium commune* in which he locates the soul. And in the lower drawing on the same page the optic nerves find clear and isolated representation. Again, on the verso of this folio, alongside his marvellous exposure of the orbit and maxillary sinus, he writes: "The eye, the instrument of vision, is hidden in the cavity above....The opening *b* [the optic foramen] is where the visual power passes to the *sensorium commune*." It was thus that he gave anatomical reality to his description of the eye as "the window of the soul."

This preoccupation with the physiology of vision even in such an unlikely anatomical context betrays the fact that the majority of Leonardo's many studies of the eye and vision are not to be found in his so-called anatomical manuscripts but are scattered about elsewhere. All of them, however, are aimed at a deeper understanding of the nature of the subjective side of "experience" as obtained from all the senses, not only the eye. In parallel with this he was attempting to analyse the nature of the objective observation of natural phenomena, such as the shape, size, and distance of objects, using the technique of perspectival proportions on the vertical glass pane. Through the combination of perspective and physiology of vision Leonardo hoped to understand how "the mind of the painter must of necessity be transformed into Nature's mind in order to act as an interpreter between Nature and Art" (Treatise on Painting, f.24v). Thus did Leonardo bridge the chasm between Science and Art.

After he felt that he had achieved an understanding of how "experience" could act as an interpreter between Nature and Art Leonardo abandoned his anatomical investigations for nearly twenty years. During these years he was developing his science of the macrocosm of the world, which he called the "terrestrial machine." Finding simple linear perspective inadequate for solving distance problems he extrapolated the principle of perspective to colour and aerial perspective. He also formed the view that similar perspectival rules could be further extended in Nature to the realm of what he called "the four powers of Nature": movement, weight, force, and percussion, acting on the four Elements of earth, air, fire, and water. All power, because it did not occupy space, he saw as "spiritual" forms of energy manifested in movement or change. Having performed innumerable experiments with pulleys, levers, mirrors, lenses, and particularly with water he came to the conclusion that these powers obeyed a perspectival or "pyramidal" form of action ("All the powers of nature have to be called pyramidal," Codex Atlanticus f.151ra).

At first Leonardo applied his rules of mechanics to the movements of man's body as a whole; to his centre of gravity, to the actions of walking, running, and swimming. Many such studies are to be found in his Treatise on Painting.

About 1495 Leonardo became friendly with the mathematician Luca Pacioli who propounded to him the works of such classical masters of mathematics as Euclid and Archimedes. This turned Leonardo's interest even more strongly towards the conviction that geometry held the key to the interpretation of Nature; and this included the effects of the "four powers" within the body of man and of animals.

The opportunity to pursue anatomy further seems to have occurred by chance during one of Leonardo's visits to the hospital of Santa Maria Nuova in Florence. He tells how "an old man a few hours before his death told me that he had passed a hundred years, and that he did not feel any bodily deficiency other than weakness. And thus while sitting on a bed in the hospital of Santa Maria Nuova in Florence, without any movement or sign of distress he passed away from this life. And I made an anatomy of him in order to see the cause of so sweet a death....This anatomy I described very diligently and with great ease because of the absence of fat and humours which much impede knowledge of the parts" (Windsor 19027 verso).

In the performance of anatomical dissection Leonardo experienced the satisfaction of putting both his artistic and scientific principles into practice. Consumed as he was by curiosity and a passion for investigation, he was never one who believed in science for science's sake. At the end of one of his paeans in praise of science he concludes abruptly with the verdict: "From it [science] is born creative action which is of much more value." And among his anatomical notes he comments: "This generation deserves unmeasured praises for the usefulness of the things they have invented for the use of men; and would deserve them even more if they had not invented noxious things like poisons, and other similar things which destroy life or the mind" (Windsor 19045 verso).

Thus when Leonardo returned to anatomical investigation he put into practice all the scientific knowledge acquired since his earlier studies some twenty years before. This time the focus of his attention was centred on the movements in man's body. He sums up his outlook well on Windsor 19060 recto, alongside a drawing of the maternal and fœtal circulations:

"Why Nature cannot give movement to animals without mechanical instruments is demonstrated by me in this book on the actions of movement made by Nature in animals. For this reason I have composed the rules of the Four Powers of Nature without which nothing through her can give local motion to these animals; and how this movement engenders, and is engendered by, each of the other three powers....We shall begin by stating that every insentient local movement is generated by a sentient mover, just as in a clock the counterpoise is raised up by man, who is its mover."

Again, right in the middle of some beautiful drawings of the anatomy of the hand Leonardo suddenly breaks out with the injunction: "Arrange it so that the book on the elements of mechanics, with its practice, comes before the demonstration of the movement and force of man and other animals; and by means of these examples you will be able to prove all your propositions" (No. 20 recto).

Leonardo's anatomical drawings can be looked at and enjoyed by many different kinds of eye. For example the eye of the artist will see in them the skill of his perspectival reduction of a three-dimensional object into a two-dimensional representation, and the delicate hatchings of light and shade giving birth to the illusion of relief. The scientific eye will appreciate the three-dimensional accuracy of what he portrays; his insistence on the demonstration of all parts from at least three aspects, from in front, behind, and the side. To this he added his uncanny power of illustrating the mechanics of the movement of joints and muscles.

Leonardo himself gave most diligent attention to developing his technique of anatomical illustration. One of many such passages (abbreviated) runs:

"This plan of mine of the human body will be unfolded to you just as though you had the natural man before you. The reason is that if you wish to know thoroughly the parts of man after he has been dissected you must either turn him, or your eye, so that you examine him from different aspects, from below, above, and from the sides....But you must understand that such knowledge as this will not continually satisfy you on account of the very great con-

fusion which must arise from the mixture of membranes with veins, arteries, nerves, tendons, muscles, bones and the blood which itself tinges every part with the same colour....Therefore it becomes necessary to have several dissections; you will need three in order to have a complete knowledge of the veins and arteries; three others for a knowledge of the membranes; three for the nerves, muscles and ligaments; three for the bones and cartilages, and three for anatomy of the bones, for these have to be sawn through in order to show which are hollow and which not....Three also must be devoted to the female body, and in this there is great mystery by reason of the womb and its fœtus..." (Windsor 19061 recto).

There is good reason to believe that Leonardo in fact carried out a great part, if not all, of this plan, for late in life he mentioned that he had dissected more than thirty bodies: and it is known that a number of small note-books (libretti) offered to and refused by the Grand Duke Cosimo II de' Medici in Florence in 1613 have since been lost.

For particular anatomical problems Leonardo devised ingenious solutions. For example, in order to clarify the action of joints as fulcra for movements of the bones he separated their surfaces. "In this way you will give the true conception of their shapes, which neither ancient nor modern writers have ever been able to give without an infinitely tedious example and confused prolixity of writing and time" (No. 19 verso). When confronted with the problem of demonstrating the relations of muscles on different planes he advocates: "Make in place of these, threads which will serve to show the positions of these muscles...and remember to make the threads in the same position as the central lines of each muscle" (No. 14 verso and Windsor 19017 recto). Thus he reduced bones and joints to levers acting on fulcra, and muscles to lines of force acting on these levers. When wishing to reveal the true shape of the ventricles of the brain Leonardo utilised his skill in sculpture, making wax casts of them by injection, and then removing the surrounding brain tissue (No. 10). When wishing to observe the movements of blood streaming out through the aortic valve of the heart he made a glass cast of the part (No. 24).

Leonardo unconsciously described himself and his own particular genius for anatomy in the following passage (Windsor 19070 verso):

"You who say that it is better to look at an anatomical demonstration than to see these drawings would be right, if it were possible to observe all the details shown in these drawings in a single figure, in which with all your ability you will not see, nor acquire knowledge of more than a few vessels.... And as one single body did not suffice for sufficiently long a time it was necessary to proceed by stages with as many bodies as would render my knowledge complete; and this I repeated twice in order to discover the differences.

"But though possessed of an interest in the subject you may perhaps be deterred by natural repugnance, or if this does not restrain you then perhaps by the fear of passing the night hours in the company of these corpses, quartered and flayed, and horrible to behold. And if this does not deter you then perhaps you may lack the skill in drawing essential for such representation; and even if you possess this skill it may not be combined with a knowledge of perspective, while if it is so combined you may not be versed in the methods of geometrical demonstration, or the methods of estimating the forces and power of the muscles; or you may perhaps be found wanting in patience so that you will not be diligent.

"Concerning which things, whether or no they have all been found in me the hundred and twenty books which I have composed will give their verdict, yes or no. In these I have not been hindered either by avarice or negligence, but only by want of time. Farewell."

KENNETH D. KEELE

Catalogue
of
Drawings

I

RECTO: *Miscellaneous Anatomical Drawings*
VERSO: *Inverted Studies of Transverse Sections of the Leg*

8³/₄ x 11⁷/₁₆ in. (222 x 290 mm.) ca. 1487– 88. One of a group of drawings at Windsor, all on the same blue prepared paper, which contain what appear to be Leonardo's earliest anatomical studies.

RECTO: Pen and brown ink over silverpoint.

The drawing bottom centre shows the artist's attempts to acquaint himself with the general positions of the main viscera (labelled with indicator lines) in the chest and abdomen—what was known as a "situs figure" in his day. Ultra-violet light reveals that the figure is wearing a hat, and that its forelock was larger than it now appears. To the left of this, in an oval section, is an attempt at cerebral localisation in the ventricles of the brain; the optic, olfactory, and acoustic nerves being traced to their hypothetical destinations (see No. 4). Under ultra-violet light the ventricles of this diagram can be seen to be marked (from top to bottom): "memoria," "chomune senso" (i.e. senso comune), and "imprensiva." The three ventricles are drawn again within the skull in the old man's head to the left. Another drawing of the skull, apparently connected with the old man's head on the left margin, is clarified under ultra-violet light immediately to the left of the situs figure. It shows the orbits from which the optic nerves issue, converging on the anterior ventricle. This is connected by a narrow channel to the middle and posterior ventricles. A third line upwards to the side of the skull suggests the acoustic nerve.

To the right, upside down, is a dissection of the leg, showing the saphenous nerve and its accompanying vein, with the strap-like sartorius muscle labelled "lacerto."

The rough sketch of viscera in the centre probably represents the organs of a dog. It is labelled, from right to left, "stomacho," "fegato," and "sangue," the latter indicating what appear to be two pleural cavities containing blood. Ultra-violet light reveals a lateral view of the viscera in the upper left corner of the sheet, on which the word "sanguine" is just visible.

16

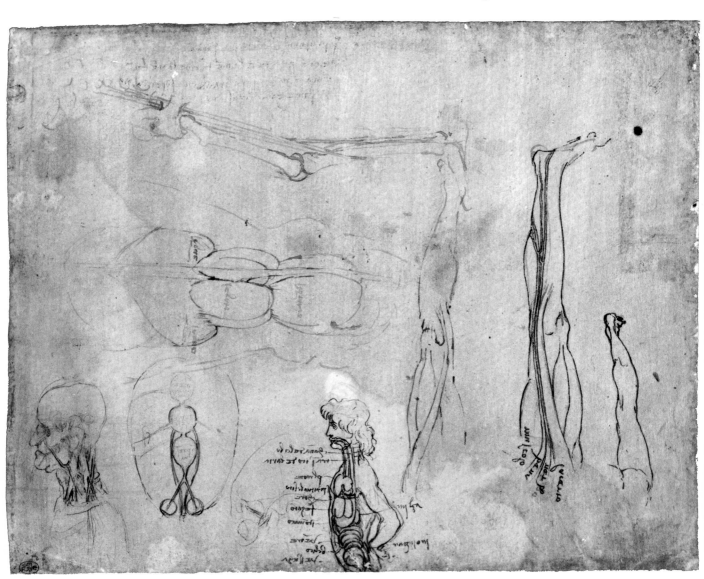

Along the top of the sheet is a sketch of the lumbar spine, pelvis, femur, and tibia, drawn to show the relation of the bones to the origins and course of the sciatic nerve. The femur with its trochanter tertius, laterally, shows that Leonardo had some knowledge of the skeleton of the horse at this time.

Several other totally new drawings appear under ultra-violet light. In the top right-hand corner are two sketches for a system of gear wheels and pinions for augmenting lifting power. The fully developed system is illustrated on Codex Madrid I, f.36v. Below these is a sketch of nerves emerging from beneath the clavicle to the arm, in a monkey (compare Windsor 12613r). To the right of the situs figure, bottom right, is a small interlacing pattern, and beneath the old man's head on the left-hand margin is a rectangular structure. Beneath the sketch of the viscera in the centre, facing to-

wards the top of the sheet, a youthful profile has appeared. In addition there are four enigmatic lines, top left, which are transcribed here for the first time by Professor Pedretti:
per prusuntione cioe presumēdo
fecie grāde elemēto cioe lamēto
e mja cōpagnj supelirano cioe soperirano
la uostra e grā cōclusione
This can be explained as a game in ambiguous talk, and shows Leonardo's love for the pun by way of alliteration (e.g. "elemento" becomes "lamento"). It may be taken as the literary equivalent of the *rebus,* the pictographs which occupied him at about the same time (cf. Windsor 12692). Only the meaning can be given in translation:
For presumption, that is presuming.
He made a great element, that is, lament.
And they will bury my companions, that is, they will assist them.
Yours is a great conclusion
[here the text breaks off].

VERSO: Pen and brown ink.

A technique of anatomical dissection tried out by Leonardo was that of making transverse sections of the leg as illustrated here at the levels indicated in the left-hand figure. In some of the surfaces so exposed diagrammatic outlines of the structures cut across have been inserted (right-hand figure). Leonardo does not appear to have used this technique very extensively; probably the circumstances in which he tried it did not help to preserve the relations of the soft structures satisfactorily, nor would they have been of much help in analysing the mechanics of muscular forces in which he was so interested.

(Windsor 12627)

17

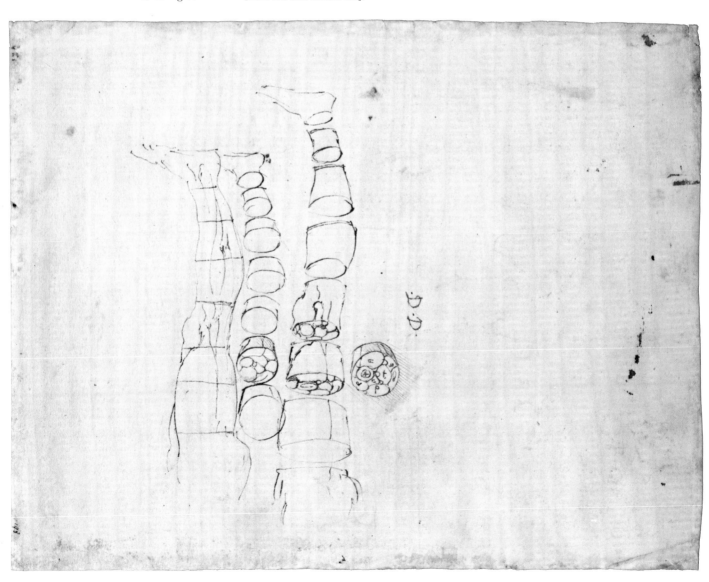

2

RECTO: *The Skull*
VERSO: *The Skull Dissected to Show the Cavities of the Orbit and Maxillary Sinus*

7⅜ x 5¼ in. (188 x 134 mm.) ca. 1489, datable owing to the close relationship between content and style of this sheet and that of another sheet of drawings at Windsor (Windsor 19059r) inscribed with the date 2nd April 1489.

RECTO: Pen and brown ink.

The upper figure of the skull was engraved by Hollar in 1645, when the drawing was in the collection of the Earl of Arundel.

Leonardo's first fully worked anatomical studies were made on the head. In these drawings of the human skull he exerted all his artistry in the perspectival creation of verisimilitude, as shown by the fine delicacy with which he represents variations in the contour of the skull bones. In this drawing the skull is shown from the side with the vault bisected in a medial sagittal section. In the lower figure this section has been carried through the whole skull, so exposing the frontal and sphenoidal sinuses, the three cranial fossae, and the nasal cavity.

The squares with crossing lines dividing up the figures are best described by Leonardo's own words to the left of the sheet: "Where the line *a–m* intersects the line *c–b* there will be the meeting place of all the senses [senso comune]; and where the line *r–n* intersects the line *h–f* there will be the axis of the cranium in the third of the divisions of the head." In another place Leonardo states that "the senso comune is the seat of the soul" and we may therefore see in this figure his exact location of the soul in the body.

18

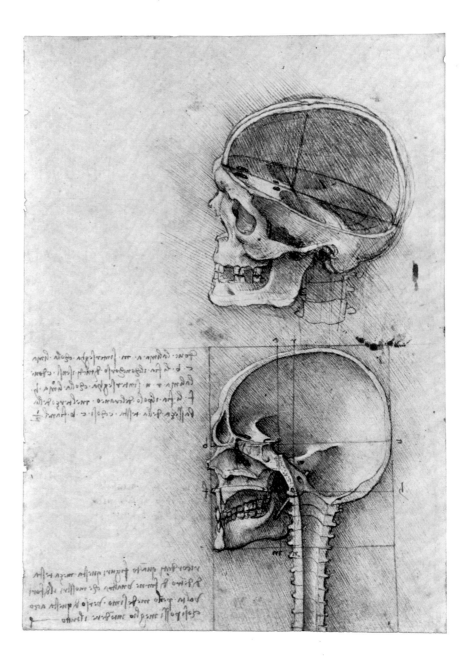

VERSO: Pen and brown ink.

Below the upper drawing Leonardo writes: "I wish to lift out that part of the bone, the support of the cheek, which is found between the four lines $a–b–c–d$ and to demonstrate through the exposed opening the size and depth of the two cavities hidden behind it." This exposure, illustrated in the lower drawing, shows the bony cavity of the orbit "in which the instrument of vision is hidden."

The cavity below this is the maxillary antrum or sinus (marked m) which, as Leonardo puts it, "contains the humour which nourished the roots of the teeth." Until these drawings were first thoroughly studied in 1901 it was believed that the maxillary antrum had been discovered by the Englishman Nathaniel Highmore in 1651.

(Windsor 19057)

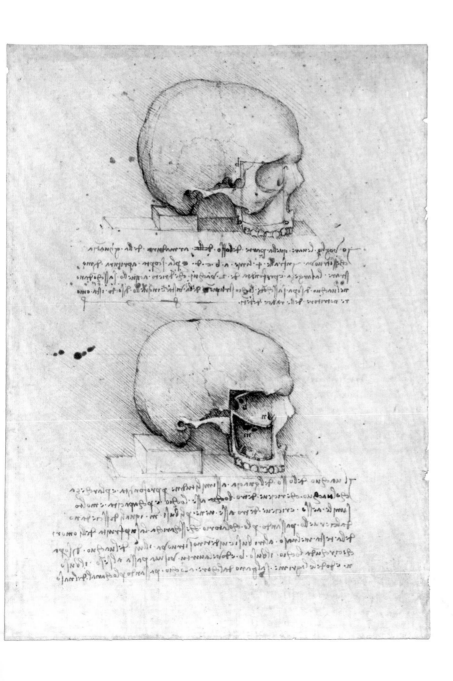

3

Muscles of the Arms and Legs

6⅞ x 5½ in. (174 x 140 mm.)
ca. 1490

Silverpoint, heightened with white, on blue prepared paper.

In this drawing Leonardo appears to be testing the emphasis of light and shade in bringing into relief the contours of the muscles of the arm and leg. The unusual conformations of some of the muscles of the arm and chest suggest that he had but limited knowledge as yet of these parts.

In the thigh he already tends to exaggerate the mass of the vastus lateralis on the outside of the thigh and give it an erroneous tendinous insertion. The surface modelling of the abdominal muscles and buttocks has a delicacy typical of this early period of his anatomical studies.

(Windsor 12637)

20

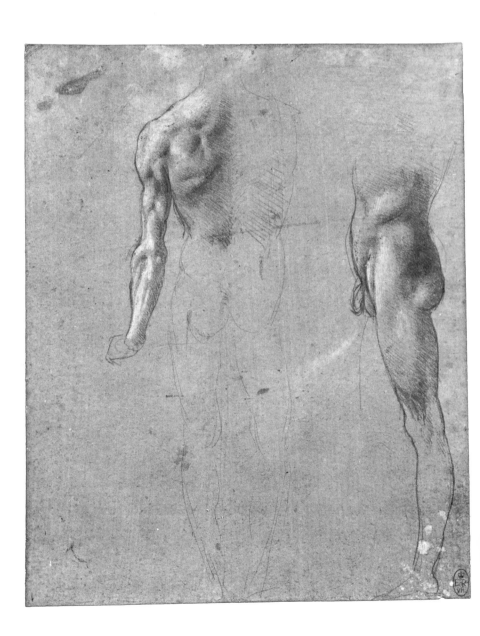

4

RECTO: *The Layers of the Scalp Compared with an Onion*
VERSO: *Sheet of Studies of the Face and Head*

8⅛ x 5⅞ in. (205 x 150 mm.)
ca. 1493–94

RECTO: Pen and brown ink over red chalk.

These early drawings are well described in Leonardo's own words: "If you will cut an onion through the middle you will be able to see and count all the covers or rinds which circularly clothed the centre of this onion. Similarly if you will cut through the head of a man in the middle, you will first cut the hairs, then the coating and the muscular flesh and the pericranium, then the cranium, and within, the dura mater, and the pia mater and the cerebrum, then again the pia and the dura mater and the rete mirabile and the fundamentum of that, the bone." These layers are labelled in the figure below and to the right.

Above the eye the frontal sinus is seen. From the similarly "onion-coated" eyeball the optic nerve runs to the cavity representing the anterior of the cerebral ventricles. In the lower right-hand corner is a horizontal sectional diagram of the upper part of the skull, with the top part hinged backwards. The figures of the ventricles in these diagrams show that Leonardo at that time had no idea of their true shape. He learnt their actual form by making a cast of them in wax (see No. 10).

VERSO: Pen and brown ink with oxidised white and some metalpoint.

This page contains a set of drawings on the right often said to represent studies of pince-nez spectacles on the nose. They are in fact studies in perspective of the

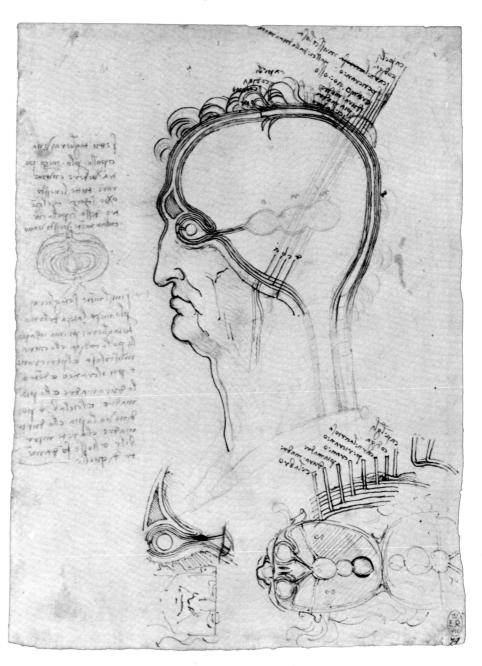

three cerebral ventricles and relate to the drawings on the recto of this folio.

The optic nerves running back from the eye-balls of the anterior of the three cerebral ventricles in all three of the lower centre and right drawings give the appearance of spectacles. In the drawing bottom right a horizontal section of the whole skull with some vessels, the ears, and acoustic nerves, is roughly sketched in perspective.

At this time (1490s) Leonardo was intensely interested in the relation between perspective, vision, and objective observation. The three small heads bottom right are an exercise in the technique of "transformation" whereby the projection of features of an anterior view can be used to construct views in perpendicular planes.

This sheet has a number of lines and drawings scratched on its surface which are made clearer when viewed under ultra-violet light. There are at least two facial profiles, one upper left facing to the left and the other inverted facing the other way. The outline of the latter drawing has been heightened with white, and is described in the Windsor catalogue as "not by Leonardo." Part of a further profile, inverted, is apparent in the upper right part of the sheet, with its eye-ball slightly to the right of that in the pen drawing of the man's head.

(Windsor 12603*)*

22

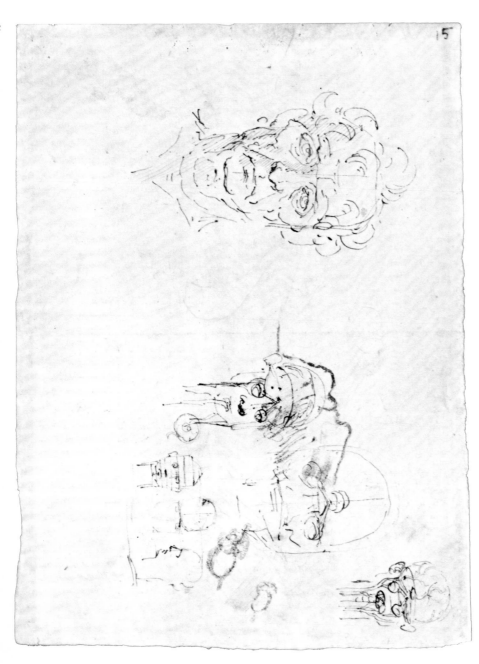

5

Optic Chiasma and Cranial Nerves

7½ x 5⅜ in. (190 x 137 mm.)
ca. 1506–08

Pen and brown ink.

The uppermost drawing shows the eye-balls, optic nerves, and optic chiasma, above which are the olfactory nerves. To the right these are placed in relation to the base of the skull and some of the cranial nerves. Leonardo showed great interest in the physiology of sensation, particularly vision. The main point of these drawings was to demonstrate the path of vision from the back of the eye-ball to the base of the brain. This he achieved with remarkable success. The olfactory bulbs and nerves are also well shown, lying above the optic nerves. He demonstrates with praiseworthy accuracy the delicate motor nerves to the muscles of the orbit, and the main (trigeminal) nerve to the face.

In the drawing below Leonardo is concerned with the blood supply of the uterus from the hypogastric artery, the remnant of which is shown curling upwards toward the umbilicus.

(Windsor 19052)

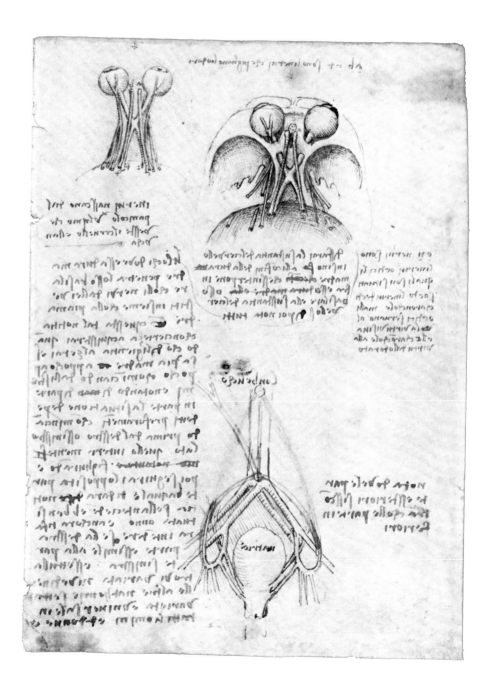

6

RECTO: *The Foetal Calf in Utero*
VERSO: *Movements of the Mouth and Lips*

7⁹/₁₆ x 5⁹/₁₆ in. (192 x 142 mm.)
ca. 1506–08

RECTO: Pen and brown ink over traces of black chalk.

The gravid uterus of a cow. The upper drawing illustrates the bicornuate (double) uterus of the cow from the outside. Below, Leonardo puts into dramatic effect his transparency technique of demonstration, producing an incomparable picture of patchy placental cotyledons and the foetal calf within. This can be seen lying upside down, its head to the left, its fore-limbs bent, with visible cloven hoofs above, and its hind limbs clearly visible to the right. Below this he draws the maternal and foetal cotyledons half-separated to show how they interdigitate "just as the fingers of the hands are interwoven, one in the space between the others…."

24

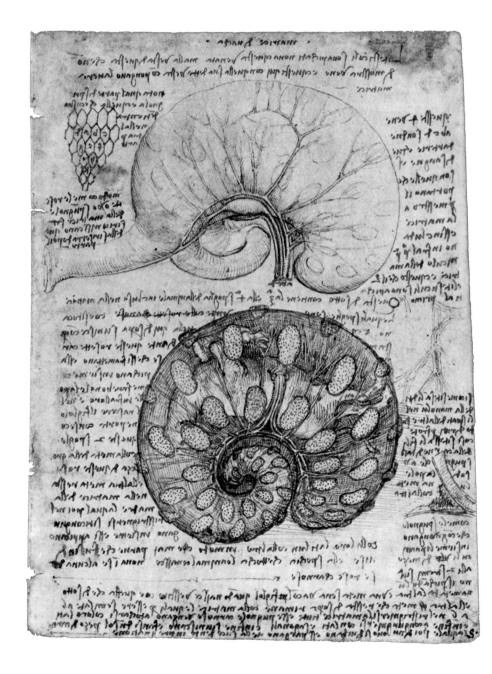

VERSO: Pen and brown ink over black chalk.

It is a far cry from these studies of the lips to the smile of the Mona Lisa, yet Leonardo was probably engaged on both at the same time. Top left is a study of pursed lips and next to it a slightly smiling mouth. Leonardo writes: "Here the lips become muscular, moving with them the lateral muscles; and when the lateral muscles constrict and shorten themselves they draw behind them the lips of the mouth and so the mouth is stretched"— first steps towards the anatomy of a smile. The sketches down the right margin show, above, retracted lips through the intact skin. Below, the skin has been removed to show how the buccinator and orbicularis oris muscles perform these movements.

The little drawing between the studies is labelled "womb of a cow." Inside the uterus can be seen the form of a little foetal calf. Leonardo develops this theme on the other side of this sheet.

(Windsor 19055)

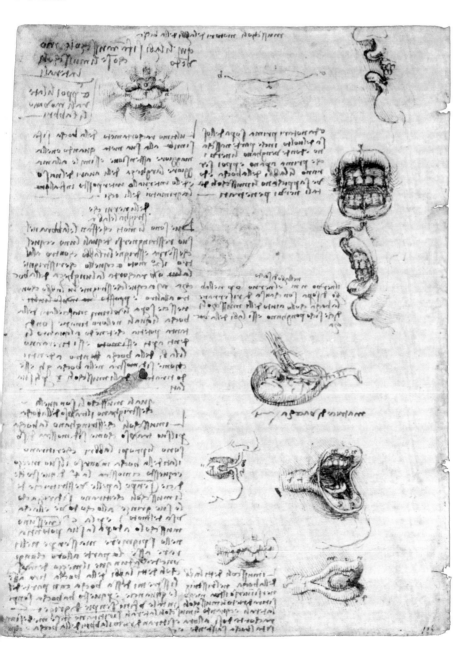

7

A Comparison of the Legs of Man and Horse

11 1/16 x 8 1/16 in. (281 x 205 mm.)
ca. 1506–08

Pen and brown ink over red chalk.

The fragmentary note in red chalk at the top of this sheet, mentioning an address in the Cordusio, the market place of the old centre of Milan, enables us to date this drawing during one of Leonardo's stays in that city, and probably 1506–08. It is an example of the artist's interest in comparative anatomy, which occupied him chiefly during the first decade of the sixteenth century.

Beneath several beautiful studies of the surface markings of the legs are drawings of a man's pelvis and legs compared with the skeleton of the hind leg of a horse. The muscles of the thighs are represented by cords to clarify their relative positions and actions. Leonardo's appreciation of the comparative anatomy of the legs of man and horse is shown by his remark on this page: "To compare the structure of the bones of the horse to that of man you shall represent the man on tip-toe in figuring the legs." Leonardo produced a treatise on the anatomy of the horse which has been lost.

(Windsor 12625)

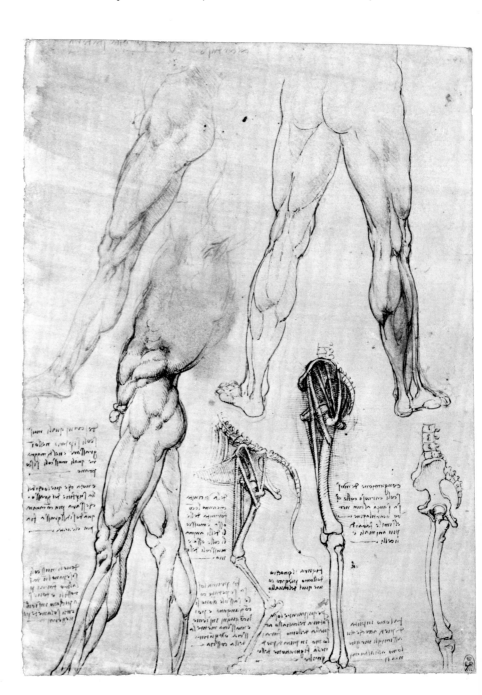

8

Lungs, Bladder and Male Genitalia

11 x 7½ in. (279 x 191 mm.)
ca. 1508–09. This sheet was origi-
nally joined to No. 9 of the pres-
ent exhibition.

Pen and brown ink over black chalk.

Apart from the drawing of a pig's lung
with its lobe lying over the heart (top
left) this page is devoted to studies of the
male genitalia and of the blood supply
to the pelvic organs, shown in the central
figure. The two masterly drawings of the
bladder and male genitalia are remark-
able for their representation of the course
of the vas deferens arising from the tes-
ticles and passing to the seminal vesicles
on the lower side of the bladder. The
accuracy with which the ejaculatory duct is
shown entering the urethra just beyond
the internal sphincter of the bladder

shows Leonardo's mastery of the anatomy
of this region. Leonardo even understood
the mechanism of hernia formation,
demonstrating here "the way the intes-
tines descend into the sac of the testicles."

(Windsor 19098 verso)

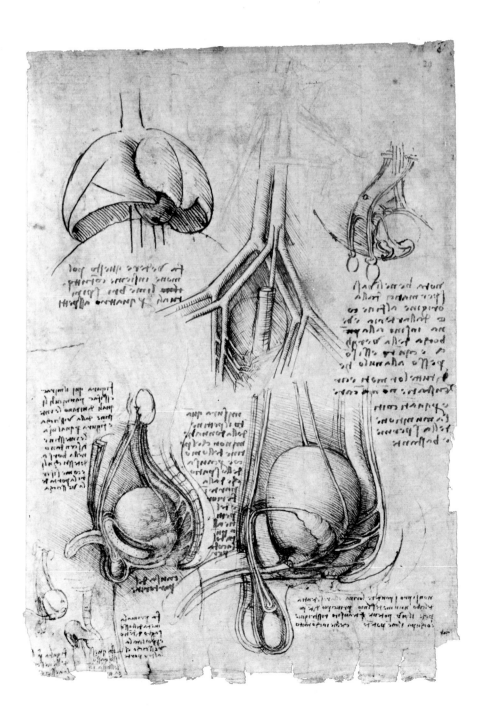

9

RECTO: *The Organs of the Chest and Abdomen from Behind*

VERSO: *The Organs of the Chest and Abdomen from the Front*

10¹³/₁₆ x 8¼ in. (275 x 210 mm.) ca. 1508–09. This sheet was originally joined to No. 8 of the present exhibition.

RECTO: Pen and brown ink and black chalk.

An example of a partly worked sheet of drawings in which the preparatory black chalk lines have not been inked over, and which is consequently difficult to interpret.

The text in the top left corner begins: "When you draw the lung make it an open work [*traforato*] in order not to impede what is behind." The central figure on this sheet is in fact largely traced through from the verso, where the organs are shown from the front.

28

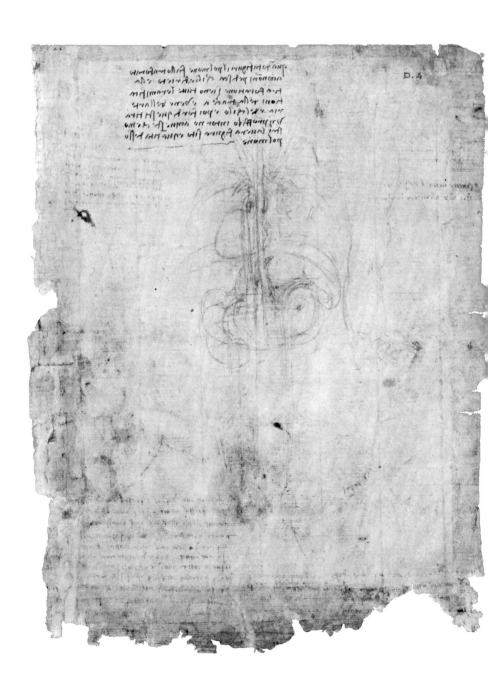

VERSO: Pen and brown ink over black chalk.

The large central figure shows the heart and abdominal viscera. Leonardo has already made detailed dissection of the bladder and male genitalia which are here well shown, including the drainage of the left spermatic vein into the corresponding renal vein. On each side of this figure Leonardo draws the heart and lungs in direct communication by inlet and output passages. At this time he still held to the traditional belief that air actually went in and out of the heart.

(Windsor 19104)

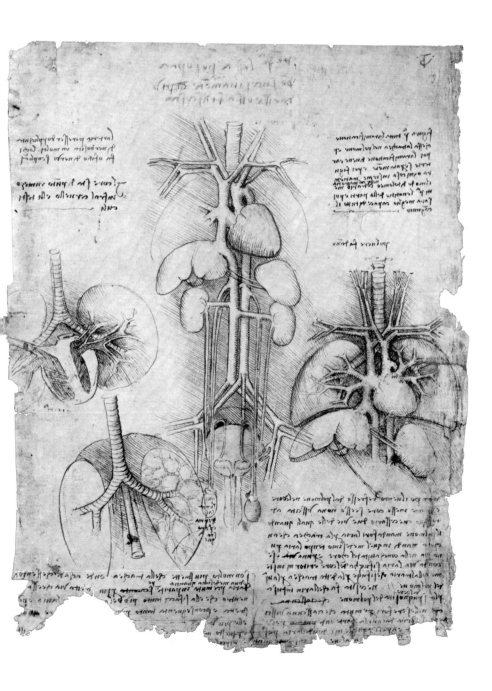

IO

The Brain

7¹⁵⁄₁₆ x 10⅜ in. (201 x 264 mm.)
ca. 1508–09

Pen and brown ink over black chalk.

The injection of parts to discover their true form is amongst the most important innovations in anatomical technique contributed by Leonardo. Here he applies it to the anatomy of the cerebral ventricles. In the upper left drawing the site of injection of melted wax is marked at the base of the third ventricle. The shape of the wax cast is seen in this and in the drawing to its right of the brain in horizontal section. It can be seen that the wax distorted the third ventricle and failed to fill the lateral ventricles completely, but it revealed the first resemblance to their true size, shape, and position. The site of injection is again marked at the centre of the rete mirabile in the bottom figure (identifying the brain as that of an ox).

The notes consist of detailed instructions of the technique of injection, which is again illustrated in the little sketch in the lower right corner.

(Windsor 19127)

30

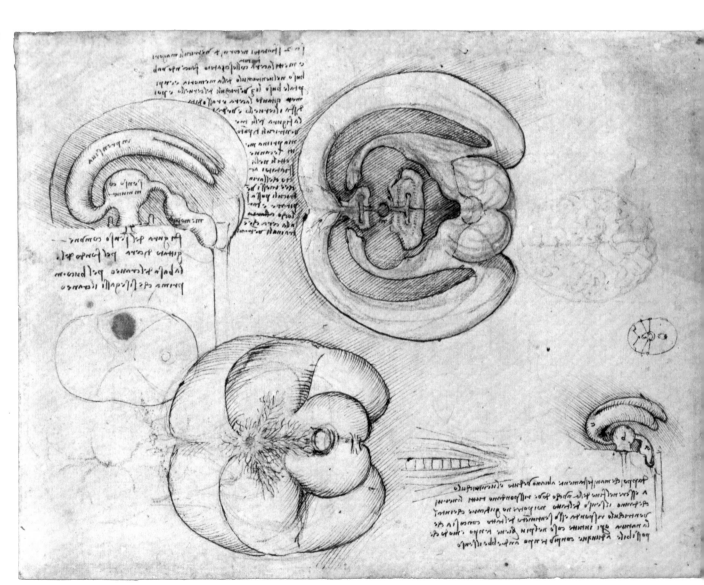

II

RECTO: *The Bones of the Foot and Surface Muscles of the Shoulder and Neck*
VERSO: *Arm Movements Made by the Biceps*

11¾ x 7¹⁵/₁₆ in. (298 x 201 mm.) ca. 1510. This sheet is the first of a group of drawings, of similar size and medium, published by Sabachnikoff as Ms. A. Nos. 11–20 of the present exhibition belong to this group and are roughly datable 1510 as this date appears on one of the drawings of the group. Carlo Pedretti has established that the sheets in this series were originally compiled in pairs. No. 11 should thus be joined to No. 12.

RECTO: Pen and brown ink with some wash modelling over black chalk.

The drawing of the surface markings of the superficial muscles of the shoulder and upper arm (top right) is found with variations on several occasions, for example on No. 13 verso. Both appear to be shaded from right to left, which is unusual for Leonardo who was left-handed. The drawings of the bones of the ankle and foot show a deep knowledge of anatomy. They are a continuation of the studies on No. 12 recto and are completed on No. 13 verso. In the top left figure the bones of the ankle and foot are drawn from behind, in the central figure from below, and in the bottom figure (upside down) from the side.

In the notes Leonardo concentrates on the sesamoid bones beneath the ball of the great toe (labelled *r* on the bottom figure) through which the tendon acts. The little sketches above study "the power of the line of movement passing through the junction of movable bodies" such as this joint. He concludes that these little sesamoid bones have been placed by Nature "under the joint of the great toe" to prevent "damage by friction under such a weight as that of a man walking."

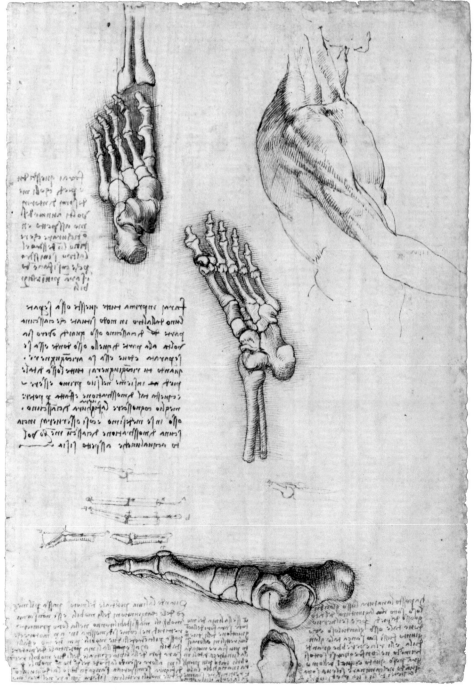

VERSO: Pen and brown ink with some wash modelling over black chalk.

These drawings illustrate Leonardo's method of demonstrating the action of muscles by laying them on to the bare levers of the bones which they move. Here the action of the biceps on the elbow joint is studied from various points of view. Its two heads (bi-ceps) are shown in the drawings, often cut, with a lip (usually lettered) to show how it is inserted into the radius of the forearm in such a way that it rotates that bone and the hand it carries so that "the palm faces the sky," i.e. supinates it.

In the bottom two drawings he shows how the "palm is turned towards the ground" (pronated) and in the lowest study he draws the muscle that does this,

the pronator teres. This discovery that the biceps rotates the hand as well as bending the elbow was a source of great joy and pride to Leonardo, who made numerous drawings of the subject.

(Windsor 19000)

32

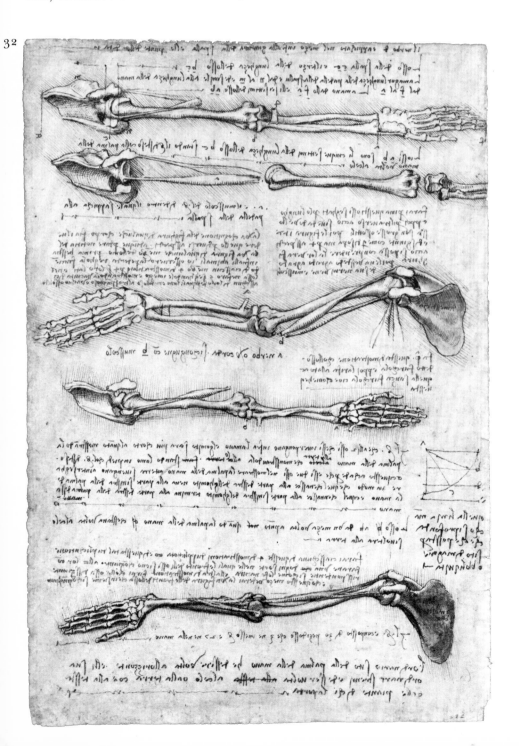

I2

RECTO: *Bones of the Foot and Shoulder*
VERSO: *Muscles of the Forearm*

11⅜ x 7¹³/₁₆ in. (288 x 198 mm.)
ca. 1510. See entry for No. 11, to
which this sheet was originally
attached.

RECTO: Pen and brown ink with wash
modelling over black chalk.

These magnificent drawings of the
bones of the foot form part of the series
to be found on Nos. 11 recto and 13
verso. It is curious that Leonardo's draw-
ings of the foot coincide with studies of
the shoulder, as in this instance, where
the central top drawing shows a deep dis-
section of the shoulder joint. The text is
concerned with making "six aspects of the
foot" with "separated bones," etc. The ses-

amoid bones, seen joined to their tendons
bottom left, receive detailed considera-
tion as to their number and situations
throughout the body. It is interesting to
find him including the knee-cap (patella)
in this list.

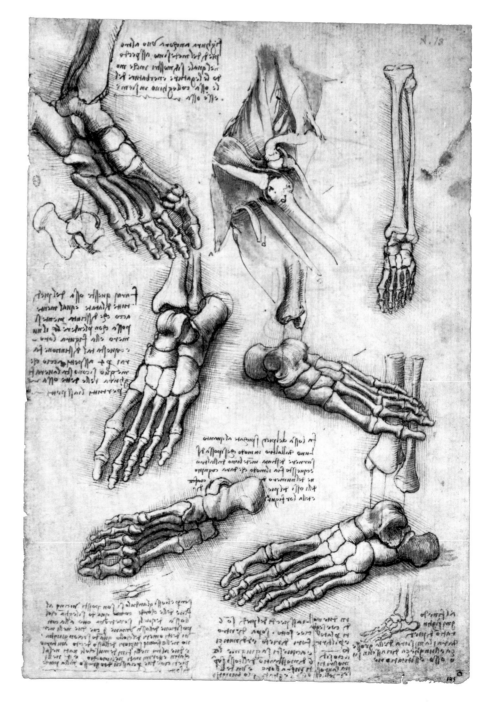

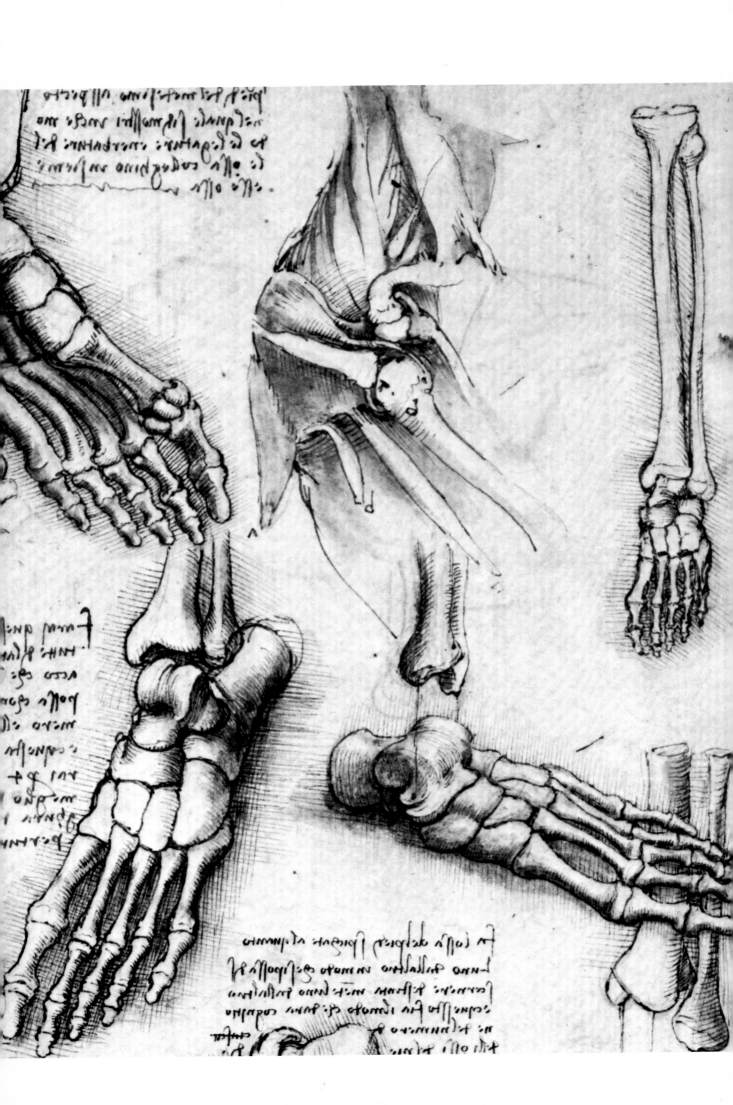

← Detail from No. 12
recto, *Bones of the Foot
and Shoulder.*

VERSO: Pen and brown ink.

The two splendid upper drawings of the arm with the hand grasping a staff show the close link between Leonardo's artistic and scientific activities. The superficial anatomy of the muscles and veins in the upper drawing will bear inspection from any anatomist, as will the deeper dissection of the lower figure. Below are two less finished drawings of the muscles of the outer arm and neck.

The text at the bottom compares the movement of a man's arm with that of a bird's wing: the wings of a bird "are so powerful because all the muscles which lower the wings arise in the chest and themselves have greater weight than those of the rest of the bird."

(Windsor 19011*)*

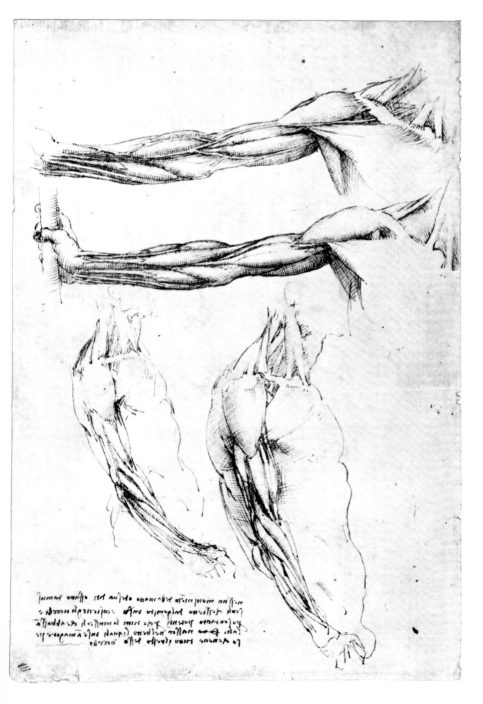

13

11 7/16 x 7 13/16 in. (290 x 197 mm.)
ca. 1510. See entry for No. 11.
This folio was originally joined to
No. 14.

RECTO: Pen and brown ink with wash modelling over black chalk, and red chalk lines top right.

Here most of the drawings show the larynx and trachea. Particular attention is paid to the epiglottis and in the drawings down the right-hand margin the epiglottis is shown in various positions. The second drawing from the top shows a food bolus passing over the epiglottis, bending it back and so closing the entrance to the larynx.

The thyroid gland is shown as a rather pendulous bilobed structure, hanging down in front of the upper rings of the trachea. Leonardo described it as being "made to fill in where muscles are lacking; they keep the trachea apart from the clavicle"—a view in keeping with Galen's ideas as to the function of glands.

The lowermost central drawings show the vocal cords. Leonardo thought that sound is formed by the vocal cords much in the same way that it is in a flute, that is by producing eddies in the air from the lung as it flows over them. He represents them, and the hollows between them known as the Ventricles of Morgagni, very accurately. They aid in making eddies of air in voice production.

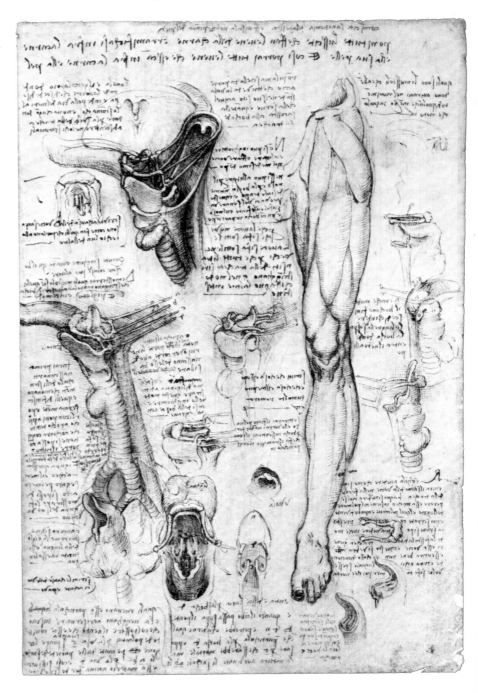

VERSO: Pen and brown ink with wash modelling over black chalk.

The studies of the foot from above complete the series begun on No. 11 recto. Leonardo often used an "exploded" view to explain joints. The rough diagram of a skeleton in the right upper corner is shown with most of its joints separated. Below it he refers to this method saying "break or disunite each bony joint from one another." He made an erroneous trial of the method on the ankle joint to the left. See No. 12 recto for a more successful effort.

The dissections of the neck in the lower three figures show Leonardo delving ever deeper into this region. The sterno-mastoid in the first two figures divides the neck into anterior and posterior triangular divisions. In the third figure this muscle has been removed to show the complexity of the muscles beneath.

The diagram on the right margin shows Leonardo's mastery of the subtle pair of muscles named digastric (two-bellied), which run backwards from the chin.

(Windsor 19002)

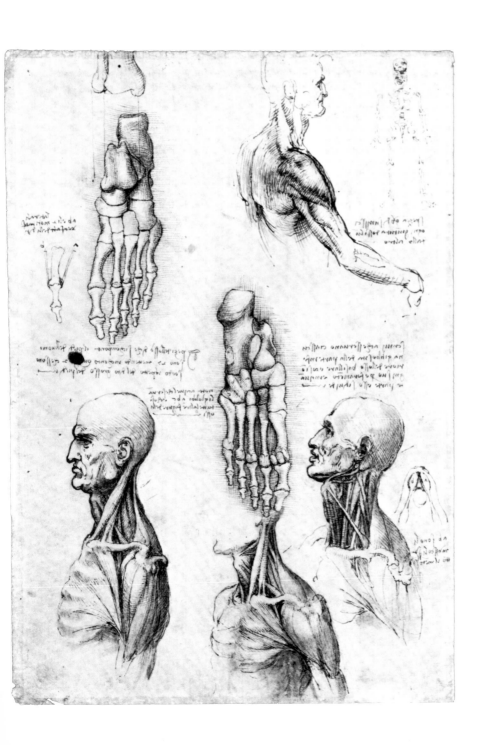

14

RECTO: *The Surface Muscles of the Neck and Shoulder*
VERSO: *The Muscles of the Shoulder*

11½ x 7¹³/₁₆ in. (292 x 199 mm.)
ca. 1510. See entry for No. 11.
This folio was originally joined to
No. 13.

RECTO: Pen and brown ink with wash modelling over black chalk.

The man's head and shoulders, top centre, were engraved by Wenceslaus Hollar in 1648 when the drawing was in the collection of Lord Arundel.

In this set of drawings of the neck and shoulder Leonardo reviews the surface markings of muscles before removing the skin for superficial dissection. The long note on the right describes the movements of the neck: "The neck has four movements. The first to raise the face, the second to lower it, the third to turn it to the right and left, the fourth to bend the head to the right and left." Other movements he calls "mixed." He ends by emphasizing the importance of the

knowledge of the muscles performing these movements "so that if a man through some wound should lose one of these movements one will be able to understand with certainty which tendon or muscle is damaged."

38

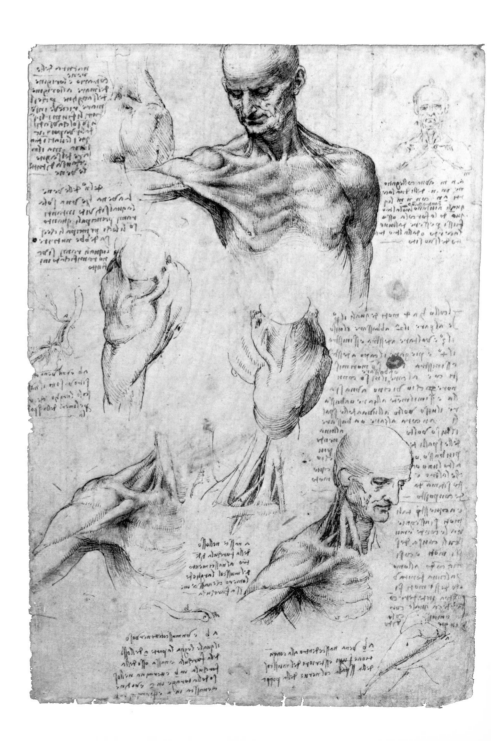

VERSO: Pen and brown ink with wash modelling over black chalk.

In these drawings Leonardo illustrates the mechanics of the movement of the shoulder joint. He approached this problem by dissection at ever deeper levels from the skin down to the articulating bones. In this dissection the actions of pectoralis major, teres major and minor, levator scapulae, supraspinatus, infraspinatus, latissimus dorsi, and the rhomboid muscles all claim his attention and each is labelled with a letter. The pectoralis major was divided by him into fasciculi which represent the lines of force along which the muscle acts.

Leonardo carried this schematic representation to its logical conclusion by representing all the muscles of the shoulder joint by their lines of force in the figure on the right margin of the sheet. Thus he reduced the forces acting on the joint to an intelligible geometrical and mechanical pattern.

(Windsor 19003*)*

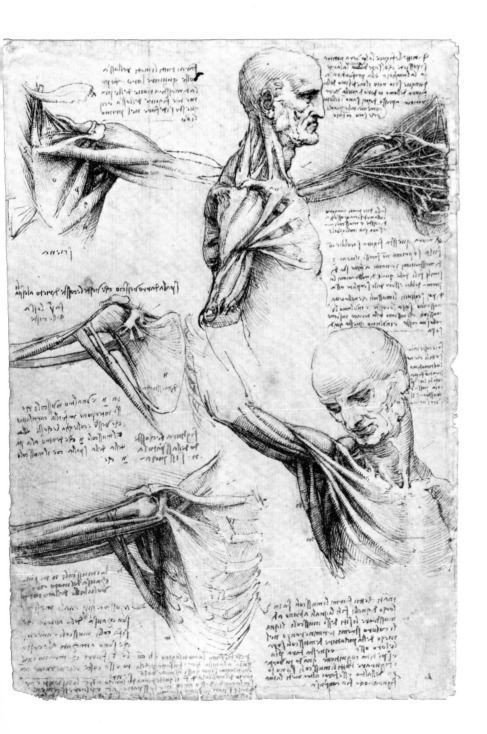

15

11 ⅜ x 7¹⁵/₁₆ in. (289 x 202 mm.)
ca. 1510. See entry for No. 11.
This sheet was originally joined to
No. 16: incised lines run from the
right-hand margin of the verso of
this sheet to the left-hand margin
of the recto of No. 16.

RECTO: Pen and brown ink with wash
modelling over black chalk.

We do not know how Leonardo pre-
pared the bones of skeletons for study
and he says nothing about it in his surviv-
ing manuscripts, but the bones in this
drawing bear witness to the success of his
technique. In the top row of drawings
Leonardo draws legs according to his
principles from all aspects—front, back,
and sides. The foot of the first drawing,
that on the right, receives special atten-
tion as a lever. Leonardo writes: "Note
here that the tendon which pulls the heel
c raises a man on the ball of his foot a, the
weight being born at the fulcrum b [the
internal malleolus of the ankle]. And be-
cause the lever bc is half the counter-lever
ba, so 400 lbs. [the weight of a man in
Florentine pounds] at c makes a force of

200 lbs. at a with a man standing on one
foot." This is good bio-mechanics.

In the kneeling figure at the centre of
the lower row he shows how the two mus-
cle cords ab and nm produce rotation of
the lower leg at the knee when it is bent,
in contrast to their action when the knee
is straight, as shown in the middle figure
of the upper row.

40

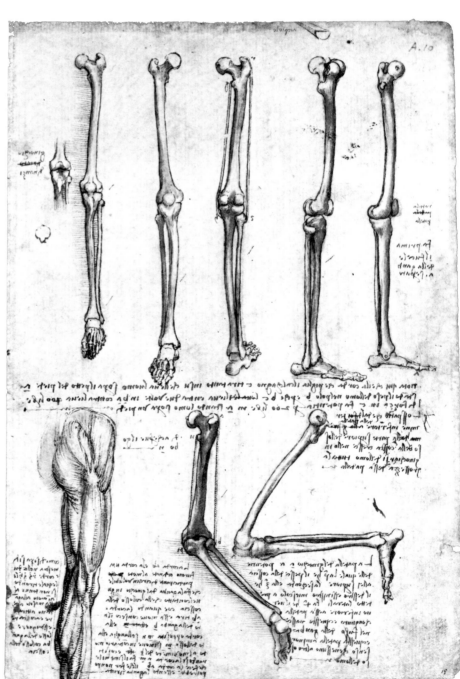

VERSO: Pen and brown ink with wash modelling over black chalk, with red chalk lines between the central figures.

The main drawings on this page continue the series of different aspects of the arm and chest begun in No. 16 verso, as a man is rotated into eight positions through an angle of 180°. Many of the muscles are lettered and their actions described. In the bottom right corner is an eight-pointed star diagram around which Leonardo writes: "I turn an arm into eight aspects, three outwards, three inwards and one to the back and one to the front."

(Windsor 19008)

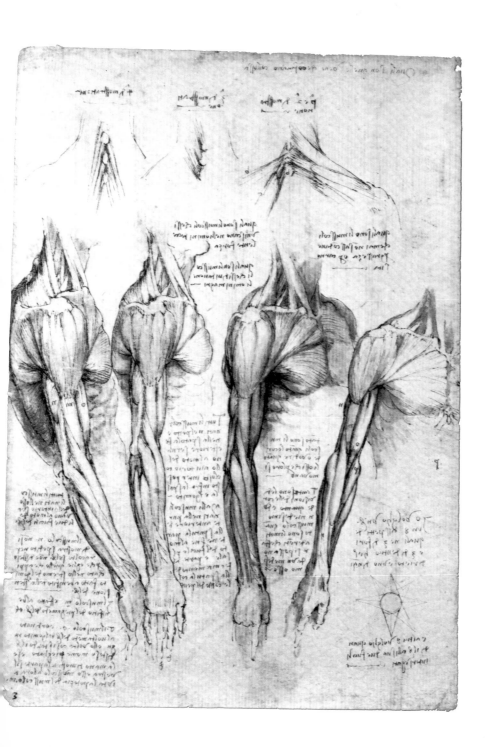

RECTO: *Superficial Muscles and Veins of the Arm*
VERSO: *Muscles of the Arm in Rotated Views*

11⁵/₁₆ x 7¹³/₁₆ in. (287 x 198 mm.) ca. 1510. See entry for No. 11. This sheet was originally joined to No. 15.

RECTO: Pen and brown ink with wash modelling over black chalk.

The right side of the page is devoted to a study of the superficial veins of arm, chest, and abdomen. The patterns of drainage of the cephalic and basilic veins of the arm, the mammary veins of the chest, and the superficial epigastric veins of the abdomen are beautifully shown. Below on the right Leonardo analyses the deeper reaches of the basilic vein, following it with its branches through the axillary vein up the subclavian to its junction with the internal jugular, labelled *m*.

The old man with covered head sketched at the top of the page may well have been the subject of dissection. His

leanness would be a valuable feature to Leonardo who repeatedly stressed its importance for anatomical work. Only in lean bodies are the superficial veins and muscles of the chest and upper arm easy to display so well as Leonardo has illustrated them here.

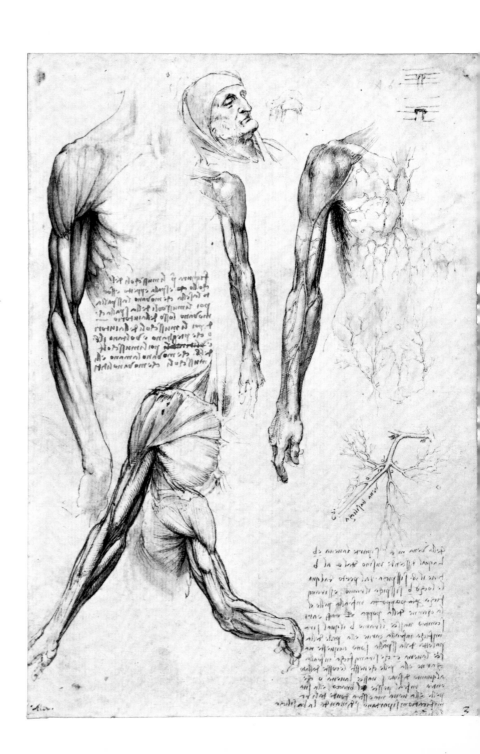

VERSO: Pen and brown ink with wash modelling over black chalk.

This series of drawings of the superficial muscles of the arm presents (from left to right) four views, commencing with that from the back and turning the body through a right angle to show the right side. The series is completed on No. 15 verso.

It will be noticed that particular attention is given to the deltoid muscle which is divided into separate slips because each of these, in Leonardo's view, exerts a different action and therefore is a different muscle.

(Windsor 19005)

43

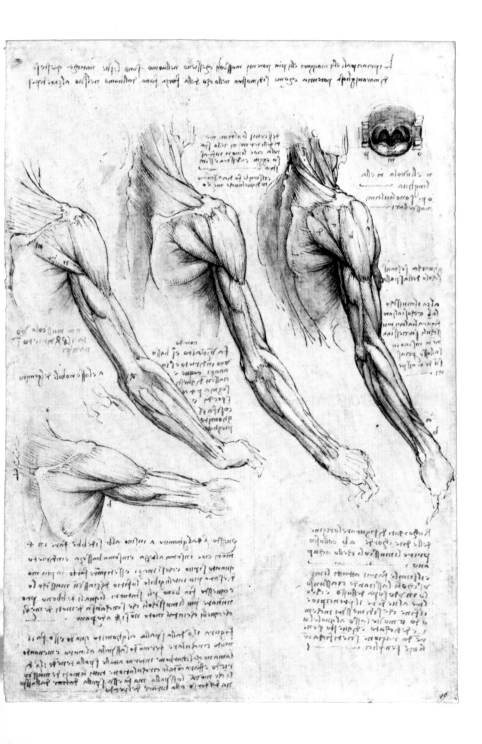

17

RECTO: *Muscles of the Thighs*
VERSO: *The Muscles of the Trunk and Legs*

11⁵/₁₆ x 8⅛ in. (287 x 207 mm.)
ca. 1510. See entry for No. 11.
This sheet was originally joined to
No. 18.

RECTO: Pen and brown ink with wash
modelling over black chalk.

On this page Leonardo advocates making his demonstrations on bodies with lean muscles "so that the space between one another will make a window to show what is to be found behind them." The accompanying chalk drawing of the shoulder and extended right arm, though faint, gives a good impression of the view in depth so obtained.

The forceful muscular figure below suggests that exaggeration of muscle outlines which Leonardo adopted at the period of his Battle of Anghiari cartoon. All through his life Leonardo looked on the tensor fasciae latae with sartorius as the main flexor muscles of the hip joint. He failed to find the psoas and iliacus muscles. Here tensor fasciae latae, labelled *b*, is seen joining the vastus lateralis, labelled *a*, on the outer side of the thigh, whilst sartorius, arising also from the anterior superior iliac spine, runs like a strong strap to the inner side of the left knee. Between the two is rectus femoris going to the knee-cap.

The notes discuss the action of the muscles and the distribution of fat in muscular men.

44

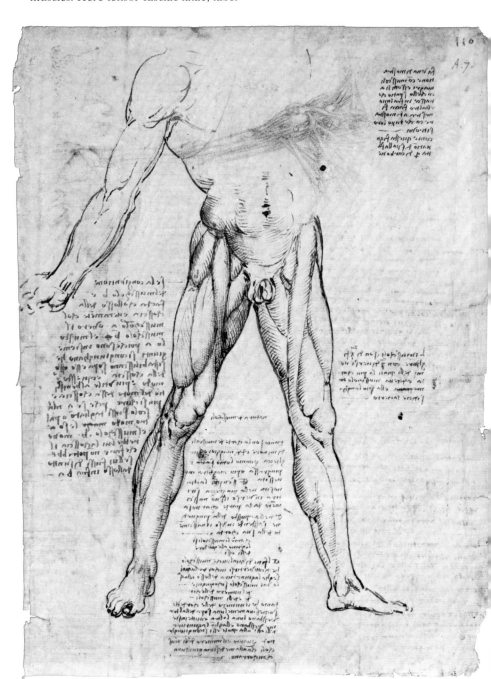

VERSO: Pen and brown ink with wash modelling over black chalk.

The full length figure on the right illustrates the superficial muscles of trunk and thigh. Most noteworthy in the trunk are the interdigitations of serratus anterior and the external oblique muscle of the abdomen on the ribs. Leonardo's text, however, concentrates on the muscles around the hip joint, the horizontal axis of the body. Once more tensor fasciae latae *a* is seen joining the vastus lateralis *e*. The other muscles *b*, *c*, and *d* are the divided gluteus medius and gluteus maximus, the muscles forming the buttocks. Considering that Leonardo calls the muscles of the buttocks "the most marvellously powerful in the body" he has given them here a surprisingly feeble representation.

The middle figure shows once more the pattern of tensor fasciae latae, sartorius, and the rectus femoris. The small figures above form part of a study of the blood and nerve supply of muscles, and on the left margin unidentifiable muscles are placed over the ribs.

(Windsor 19014)

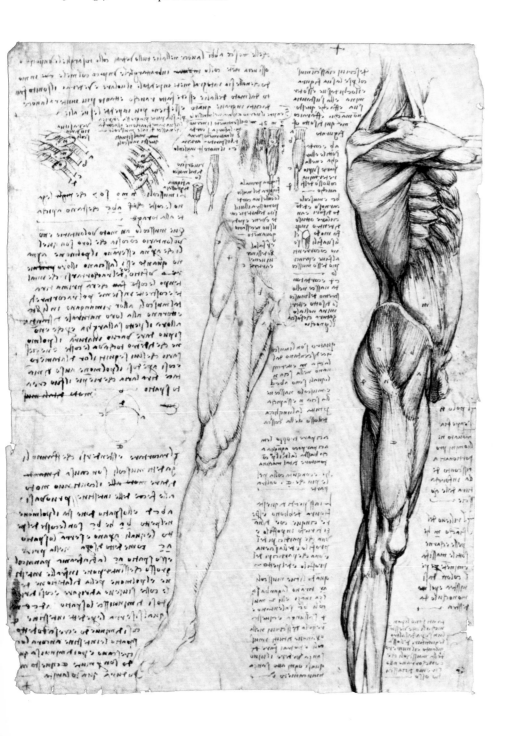

18

RECTO: *The Muscles of the Spine*
VERSO: *Stabilisation of the Cervical Spine*

11 $^{7}/_{16}$ x 8⅛ in. (290 x 206 mm.)
ca. 1510. See entry for No. 11.
This sheet was originally joined to
No. 17.

RECTO: Pen and brown ink with wash
modelling over black chalk.

On this page Leonardo completes the
study he began at the top of No. 15 verso.
As usual the progress of dissection goes
from right to left and working down the
page. The first shows the muscles of
spine, scapula, and shoulder. For some
reason Leonardo hardly ever draws the
trapezius muscle accurately. Each figure
shows a deeper dissection; and with
greater complexity, greater inaccuracies.
Eventually he evolved the idea that each
vertebra is stabilised by muscles acting
on the vertebral spines from below and
above, whilst others acting more laterally
bend the spine. This pattern is then
crystallised into the "lines of force" shown
in the cord diagram, bottom right. Here

the stabilising action of ten attached ten-
dons is shown on one cervical vertebra. It
is drawn again in more detail to the left
of this. This sheet should be compared
with No. 25.

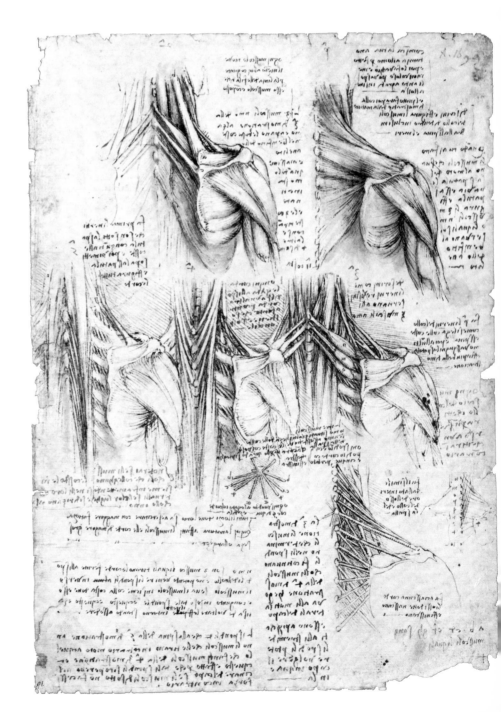

verso: Pen and brown ink over black chalk.

This page is devoted to the problem of "How the cervical spine is stabilised." Leonardo is keen to show that a group of muscles arising from the ribs run up to the spine and steady it when they act in one direction whilst helping to raise the ribs when they act in the opposite direction. These muscle bellies and tendons (serratus posterior superior) are shown in the upper figure.

In the lower two figures he compares the action of muscles on the cervical spine to the stays on the mast of a ship. This is drawn diagrammatically on the right and applied to the anatomy of the upper rib and cervical spine in the figure to its left.

(Windsor 19015)

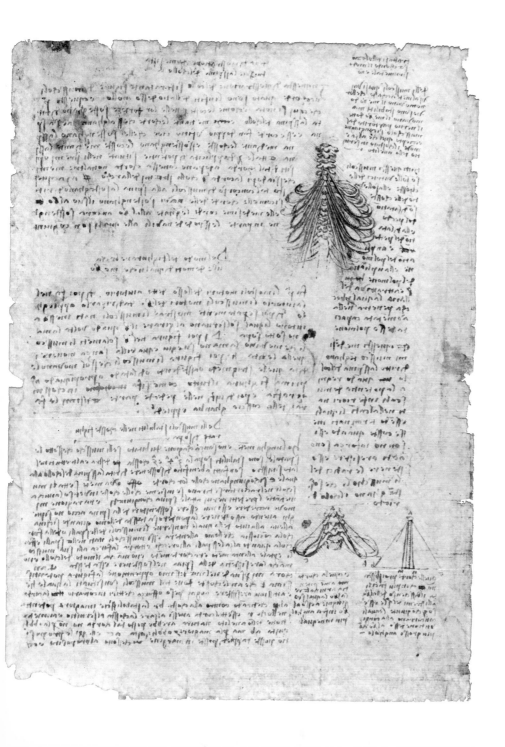

19

RECTO: *Surface Anatomy of the Neck and Shoulder*

VERSO: *The Spine*

11 7/16 x 7 15/16 in. (290 x 201 mm.)
ca. 1510. See note to No. 11.

RECTO: Pen and brown ink and black chalk.

In the bottom left-hand corner of the sheet is the word 'Leoni', which is perhaps the signature of the sculptor Pompeo Leoni who once owned the collection of drawings by Leonardo now at Windsor.

The drawing shows the surface anatomy of the neck and shoulder in an old thin man, possibly the same subject as that portrayed in No. 15 recto. The raised arm, flexed at the shoulder, brings the triceps muscle into marked relief.

48

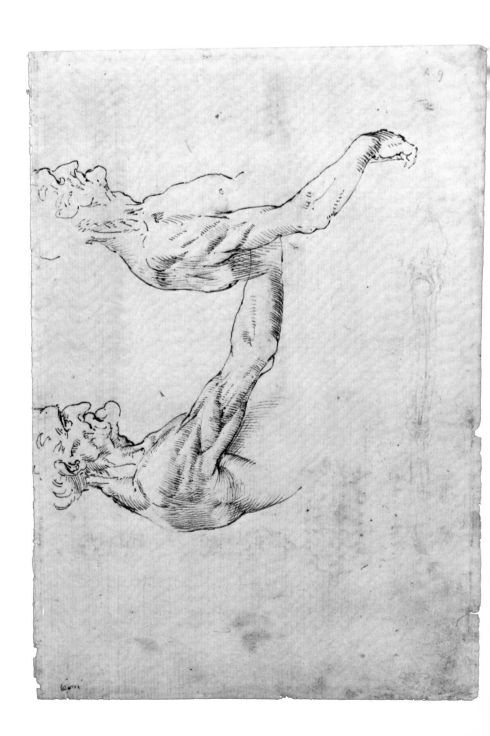

VERSO: Pen and brown ink with wash modelling over traces of black chalk.

On the upper half of the page the articulated human vertebral column is shown in all the beauty of its natural curvatures and with correctly numbered vertebrae in each part. Never had this been achieved before. To the right the vertebral column seen from the front is so skilfully drawn that one can see the curvatures in its perspective. Below, Leonardo lays it on its side to draw it from the back. To the left of this he studies the seven vertebrae of the neck. Further to the left his fascination with the unusual conformation of the first three cervical vertebrae led him to give a separate "exploded" posterior view of their articulations. "You will draw these bones of the neck from three aspects united and three aspects disunited," Leonardo writes, "and thus you will give a true knowledge of their shapes, a knowledge that neither ancient nor modern writers could have given without an immense, tiresome and confused amount of writing and time." Elsewhere on the page Leonardo expresses his intention to publish his anatomical studies.

(Windsor 19007)

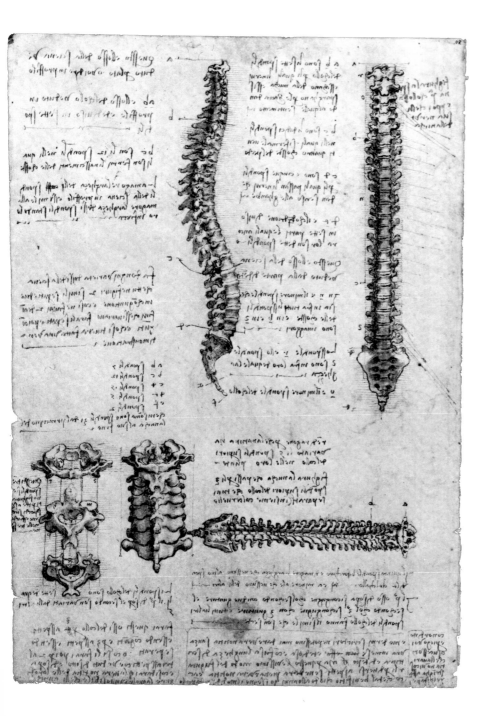

RECTO: *Dissections of the Hand*
VERSO: *Bones of the Hand*

11⅜ x 7¹⁵/₁₆ in. (288 x 202 mm.)
ca. 1510. See note for No. 11.

RECTO: Pen and brown ink with wash modelling over traces of black chalk.

The upper drawings on this page illustrate the course of the flexor tendons of the fingers at the wrist across the palm of the hand to their insertions in the phalanges. A careful study of the exact mode of insertion is made in the small central figure—the flexor digitorum profundis tendon being shown piercing that of the flexor digitorum sublimis.

The action of these tendons in bending the finger is shown in the two small figures in the lower right-hand corner. A deeper dissection of the small muscles of the hand lies to the left of this, and finally on the left are the bones of the wrist and hand.

The text on this page consists mostly of precepts on how best to illustrate the various parts of the hand in "ten demonstrations." Around the central upper figure Leonardo writes: "Make the book on the elements and practice of mechanics precede the demonstration of the movement and force of man and other animals, by means of which you will be able to prove all your propositions."

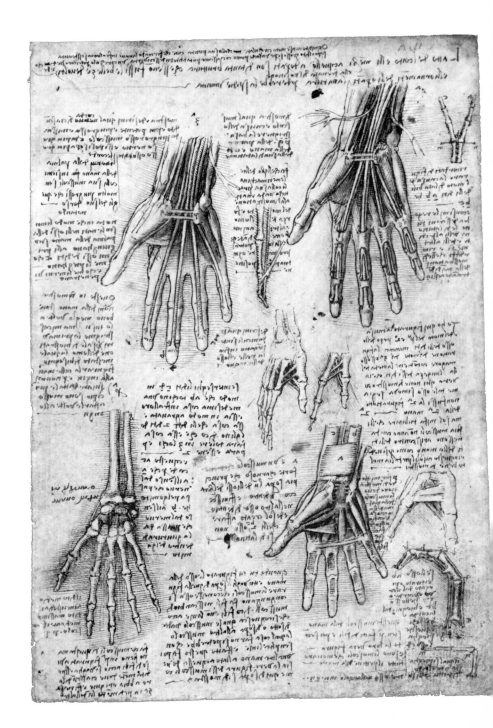

VERSO: Pen and brown ink over traces of black chalk.

A set of drawings of the bones of the hand, notable for being the first of their kind for accuracy, particularly in the representation of the separate bones of the wrist. According to his principles of demonstration, Leonardo draws the parts from the back (top left), front (right), and both sides (below).

On the right margin are beautiful studies of the tendons of a finger, each carefully labelled: "*a* is the cord which straightens the bent finger [i.e. extensor digitorum]. *e* is the cord which bends the straight finger [i.e. flexor digitorum]… *c* is the nerve which gives sensation. This having been cut the finger no longer has sensation even when placed in the

fire." Leonardo's phraseology reminds one that in his time these structures had no names. The small sketch below these notes shows how the flexor tendons stand out with a clenched fist.

(Windsor 19009)

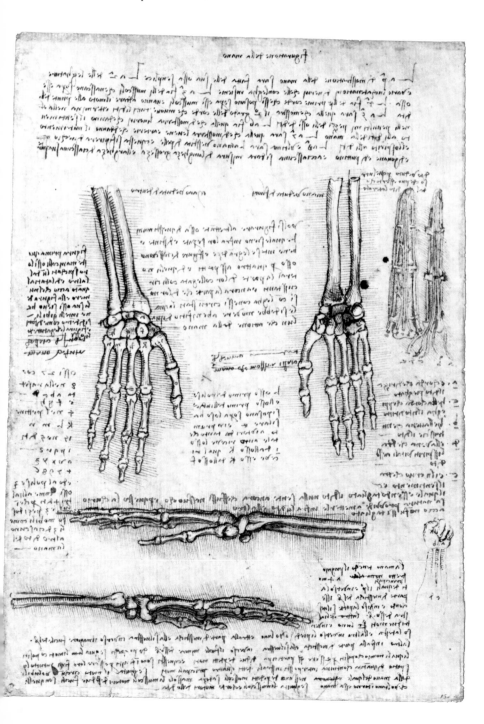

2I

RECTO: *The Infant in the Womb*
VERSO: *Dissection of the Human Foetus*

12 x 8 11/16 in. (305 x 220 mm.)
ca. 1510–12

RECTO: Pen and brown ink with red and black chalk.

Here Leonardo displays "the great mystery" of the womb: how it encloses the growing foetus within. He has sliced open a uterus containing a five-month old foetus making a breech presentation. Coiled beneath it is the umbilical cord which Leonardo believed to be as long as the foetus at all stages of its growth. He believed too that the heel of the foetus pressed into the perineum stopping urine from passing out of the bladder. In the vascular walls of the uterus Leonardo shows scattered interdigitating processes, the cotyledons. These are in fact present in ungulates such as cows but not in human beings. Outside the uterus, on the left, the ovary is seen.

The remaining drawings show the inter digitations by which the foetus is joined to, yet separated from, the mother's placental blood supply. To the right of th main drawing the infant is seen through the transparent amniotic membrane, floating and growing in its waters just as, in Leonardo's view, the Earth grows out of its surrounding seas.

52

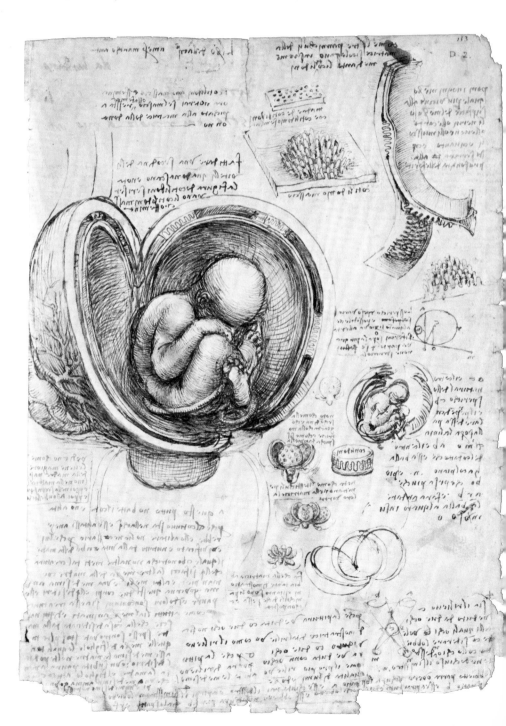

VERSO: Pen and brown ink.

The four lines of writing at the top of this page and two diagrams concerned with the formation of shadows below and to the right are in the hand of Francesco Melzi, Leonardo's favourite pupil, who inherited all his notebooks and papers. At the bottom of the page are six lines of manuscript in an unknown hand.

This "working" page of notes, though not very attractive to look at, is typical of those in which Leonardo develops his ideas at different times through small sketches and jottings. There are notes on subjects such as blood vessels, membranes, and the intestines of infants. At the centre is a drawing of the heart, liver, stomach, and intestines of the foetus. He is struck by the way "the liver withdraws to the right side" in the adult, as compared with the foetus.

(Windsor 19102)

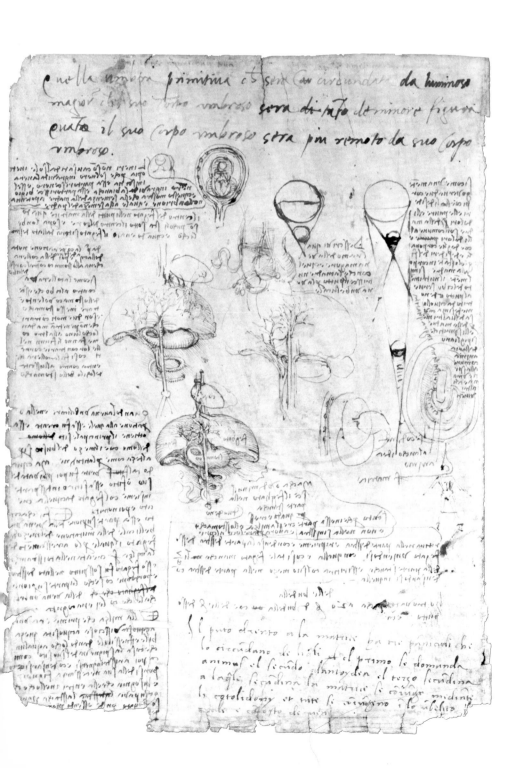

22

RECTO: *Studies of the Movement of Water*
VERSO: *Studies of the Thorax of an Ox*

11⁵/₁₆ x 8⅛ in. (287 x 206 mm.)
ca. 1513

RECTO: Pen and brown ink.

There are no anatomical notes on this page. The upper two paragraphs in small writing are concerned with the construction of floats that will "combine heaviness and lightness equal to the weight of the water. Then no part will rise above the surface of the water but it will stay under the surface in whatever part it is left." A series of floats constructed to stay at different depths is illustrated (upside down) on the verso of this page at the right margin. The drawing lower right appears to show the convergence of two streams of water.

54

VERSO: Pen and brown ink.

Leonardo was always interested in the difficult mechanics of the muscles of the ribs and spine. He sensed unsolved problems. In this series of drawings he pursues the question by dissecting an ox. The central drawing on the left margin shows the longissimus dorsi muscle of the ox arising from the brim of the pelvis and ascending as what Leonardo calls a "compound" muscle, to the upper thoracic spines. There is still the similarity to the "stays of the mast of a ship" mentioned in No. 25 verso.

Apart from the drawings of floats on the right of the page the remaining draw-

ings are studies of the muscles of the thorax and diaphragm (top left and bottom right).

(Windsor 19108)

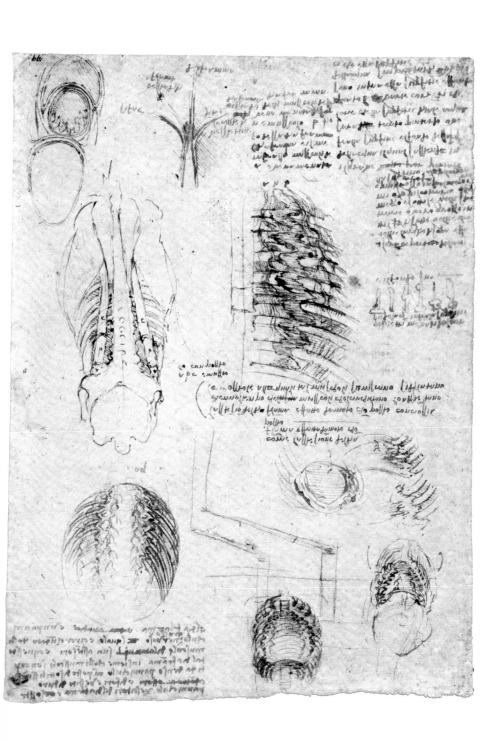

23

RECTO: *The Heart and Lung*
VERSO: *The Heart*

11⅜ x 8¹/₁₆ in. (288 x 204 mm.)
ca. 1513. This sheet is one of a
series on blue paper, one of which
bears the date 9 January 1513.
The drawings of this series are
therefore among Leonardo's last
datable works.

RECTO: Pen and brown ink.

On this page the divisions of the tra-
chea into its bronchi are shown, these
branches being accompanied by the bron-
chial arteries shown arising from the aorta.
Leonardo describes both the bronchial
and pulmonary arteries, and on this page
discusses why nature duplicates the
blood supply to the lung: "Nature gave
the trachea such veins and arteries as
were sufficient for its life and nourish-
ment and somewhat removed the other
large branches from the trachea to
nourish the substance of the lung with
greater convenience" (the word "trachea"
is used here to describe the whole bron-
chial tree).

To the right of the main drawing there
are two small figures of the "trachea min-
ima" or smallest bronchi shown dilated

as in inspiration and narrowed as in expira-
tion. The structure of the trachea
is represented at the right margin of
the page. At the bottom of the lung a circle
may be seen with a line running from it
to a sentence of script which reads: "Na-
ture prevents the rupture of the ramifica-
tions of the trachea by thickening the sub-
stance of this trachea and making thereof
a crust, like a nutshell, and it is cartilagi-
nous and this with such a hardness as a cal-
lus repairs the rupture, and in the inte-
rior remains dust and watery humour." In
these words Leonardo makes one of the
earliest descriptions of a tuberculous cav-
ity in the lung.

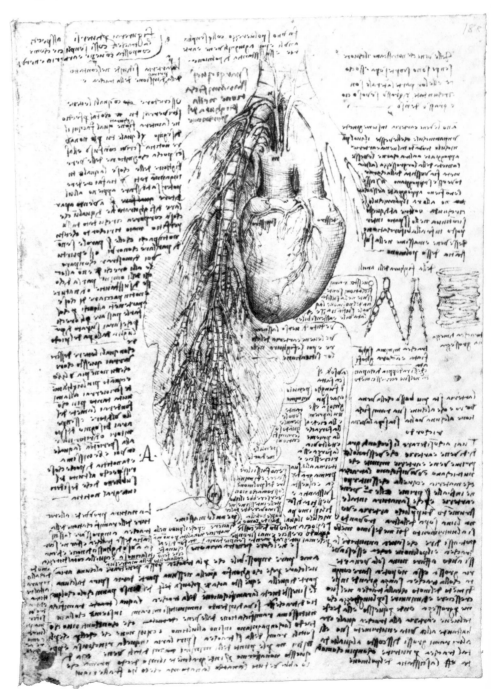

VERSO: Black chalk.
 A faint sketch of the heart of an ox
from the back.

(Windsor 19071*)*

The Blood Flow through the Aorta

11⅛ x 8⅛ in. (283 x 205 mm.)
ca. 1513. See entry for No. 23.

Pen and brown ink on blue paper.

Inside the sketch of the aorta at the top right corner of the page Leonardo gives instructions for making a glass model in order to observe the movements of water, and so blood, as it passes through the aorta. To the left are some projected models of the aorta with valves. Other models exist on other sheets.

Below to the right he draws the eddies made by blood percussed by the heart, passing through the aortic valves and being reflected in a circular eddy to close the cusps in a vertical position like that of praying hands, not horizontally.

(Windsor 19082)

25

The Muscles of the Neck

10^{15}/$_{16}$ x 8^{5}/$_{16}$ in. (277 x 211 mm.)
ca. 1513. See entry for No. 23.

Pen and brown ink on blue paper.

This is one of Leonardo's last anatomical drawings. It is designed to show how the neck is stabilised by muscles arising from the shoulder girdle so that the head can move freely on this firm axis. "You will first make the cervical spine without the skull with its cords, like the mast of a ship with its stays. Then make the skull with its cords which give it movement on its fulcrum."

The drawings illustrate how much of his detailed anatomy Leonardo had forgotten since he made the drawings on No. 18, for instance, though retaining their central theme. This sheet expresses in anatomical language the pathos of his age and infirmity.

(Windsor 19075 verso)

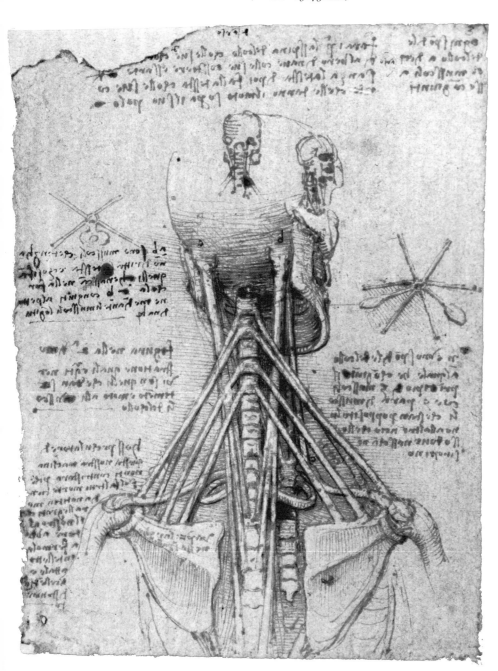

The numerical references to drawings at Windsor in the text are the Royal Library inventory numbers. These numbers are followed in the catalogue of the drawings by Leonardo da Vinci in the Royal Collection in which each drawing is discussed and illustrated (*The Drawings of Leonardo da Vinci in the Collection of Her Majesty The Queen at Windsor Castle by* Kenneth Clark. *Second edition revised with the assistance of* Carlo Pedretti, 3 volumes, London, 1968–1969; Volume III of this series is by Carlo Pedretti and is devoted almost exclusively to anatomical manuscripts and drawings; see also Appendix C in Volume I for a full discussion of their chronology). The Corpus of Leonardo's Anatomical Studies at Windsor will appear in a new facsimile edition during the next few years (Kenneth Keele and Carlo Pedretti editors). This edition will supersede the three separate publications issued around the turn of the century, as follows: *I manoscritti di Leonardo da Vinci della Reale Biblioteca di Windsor. Dell'Anatomia, Fogli A, pubblicati da* Teodoro Sabachnikoff, *transcritti e annotati da* Giovanni Piumati, Paris, 1898; *Fogli B* in the same series, published at Turin in 1901; *Fogli C* published later as *Quaderni d'Anatomia,* edited by O. C. L. Vangensten, A. Fonahn, and H. Hopstock, 6 volumes, Christiania, 1911–1916. Most of the anatomical drawings are also to be found in the following modern editions: *Leonardo da Vinci on the Human Body,* edited by Charles D. O'Malley and J. B. de C. M. Saunders, New York, 1952; Sigrid Esche, *Leonardo da Vinci: Das anatomische Werk,* Basel, 1954; P. Huard, *Léonard de Vinci: Dessins Anatomiques,* Paris, 1968. Basic illustrations of Leonardo's anatomical studies include: Elmer Belt, *Leonardo the Anatomist,* Lawrence, Kansas, 1955; K. D. Keele, *Leonardo da Vinci on Movement of the Heart and Blood,* London, 1952; and J. Playfair McMurrich, *Leonardo da Vinci the Anatomist (1452–1519),* Washington and Baltimore, 1930.

Measurements are given in inches and millimetres, height preceding width. The drawings are on white paper unless otherwise indicated. The catalogue has been arranged chronologically, as follows:

No.	Windsor	No.	Windsor
1	12627	14	19003
2	19057	15	19008
3	12637	16	19005
4	12603	17	19014
5	19052	18	19015
6	19055	19	19007
7	12625	20	19009
8	19098	21	19102
9	19104	22	19108
10	19127	23	19071
11	19000	24	19082
12	19011	25	19075
13	19002		

The concordance of Windsor inventory numbers with catalogue numbers is as follows:

Windsor	No.	Windsor	No.
12603	4	19015	18
12625	7	19052	5
12627	1	19055	6
12637	3	19057	2
19000	11	19071	23
19002	13	19075	25
19003	14	19082	24
19005	16	19098	8
19007	19	19102	21
19008	15	19104	9
19009	20	19108	22
19011	12	19127	10
19014	17		